PAINTING THE SEASONS IN WATERCOLOR

PAINTING THE SEASONS IN WATERCOLOR

BY ARTHUR J. BARBOUR

WATSON-GUPTILL PUBLICATIONS/NEW YORK

PITMAN PUBLISHING/LONDON

Copyright ©1975 by Watson-Guptill Publications

First published 1975 in the United States and Canada by Watson-Guptill Publications,
a division of Billboard Publications, Inc.,
One Astor Plaza, New York, N.Y. 10036

Library of Congress Cataloging in Publication Data
Barbour, Arthur J 1926–
 Painting the seasons in watercolor.
 Bibliography: p.
 Includes index.
 1. Water-color painting—Technique. 2. Seasons in
art. I. Title.
ND2420.B35 1975 751.4'22 74-34136
ISBN 0-8320-3858-0

Published in Great Britain by Sir Isaac Pitman & Sons Ltd.,
39 Parker Street, London WC2B 5PB
ISBN 0-273-00910-9

Manufactured in the U.S.A.

First Printing, 1975

This book is dedicated to honor
St. JOSEPH THE WORKER, head of
the HOLY FAMILY, and to my own family:
My wife, Margie, and our children
Maureen
Arthur
Gregory
Peter
and in special memory of our beloved son
Joseph James

Acknowledgments

I am gratefully indebted to the people who were ever gracious in their contributions to the development of this book:

First, my wife, Margie, for her constant support and thoughtfulness in making the time possible to produce this book.

Mr. Henry Gasser, to whom I feel thankful for writing the Foreword for *Painting the Seasons in Watercolor*. Mr. Bernard Guerlain of Special Papers, Inc., West Redding, Connecticut, for his special technical knowledge regarding the Arches watercolor papers that I used for all the demonstrations.

Mr. Stanley Hufschmidt of West Milford, New Jersey, for his photographic advice and expertise. Alfred Latini of Paterson, New Jersey, for his help and advice in photographing the chapter on Tools and Techniques. Mr. Robert Gibson of Ringwood, New Jersey, for the author's photograph on the back of the jacket and also for the photograph in Problems and How to Correct Them on page 144.

The Ford Motor Company for permission to reproduce *Catermount #2*, which is in their permanent collection and appears on pages 150-152 in Problems and How to Correct Them.

Nancy Levine of Ringwood, New Jersey, for typing the manuscript and Shirley Nebiker of Ringwood, New Jersey, for typing portions of the manuscript. Mr. Donald Holden of Watson-Guptill Publications for helping to make this book possible. Diane Hines of Watson-Guptill for her knowledgeable advice. Sue Davis of Watson-Guptill Publications for editing.

Rev. Lawrence Burke, OFM, Art Director of *Friar Magazine*, of Butler, New Jersey, for his advice in the sections on mixing shadow tones and tips on composition in the chapter on Tools and Techniques.

Last, but by no means least, my parents, Dr. and Mrs. Peter J. Barbour, for their contribution to this book.

CONTENTS

Foreword, 8
Introduction, 10

Tools and Techniques, 11
Paper, 11
Colors, 13
Mixing Shadow Tones, 15
Brushes, 16
Other Tools for Applying Paint, 18
Lift-out Tools, 20
Other Equipment, 22
How to Stretch Watercolor Paper, 23
Lighting Conditions, 24
Painting Outdoors, 24
Tips on Composition, 24

Trees

1. Bare Softwood Tree, 28
2. Bare Hardwood Tree, 30
3. Leafed-out Tree, 32
4. Pine Tree Covered with Snow, 34
5. Pine Tree in Summer, 36
6. Birch in Snow, 38
7. Birch in Summer, 40
8. Bushes and Weeds in the Foreground, 43
9. Woodland Path in Summer, 45

Water

10. Stream with Rocks in Summer, 50
11. Waterfall in Summer, 53
12. Inlet in Winter, 56
13. Seacoast in Summer, 60

Color Demonstrations

1. Woods in Late Spring, 66
2. Bright Fall, Woods and Stream, 69

3. Midsummer's Meadows and Pond, 72
4. Autumn Pond, 76
5. Woods in Winter, No Snow, 80
6. Mountain in Winter, 84
7. Early Fall Shower, 88
8. Wooden Fence in Early Winter, 92

Weather Effects

14. Spring Rainstorm, 98
15. Summer Thunderstorm, 101
16. Snowstorm, 104
17. Spring Mist, 107

Rocks, Hills, and Mountains

18. Snow-Covered Rocks, 112
19. Summer Hills, Summer Growth, 115
20. Mountains with Snow, 118
21. Mountains with Summer Growth, 121
22. Bare Mountains in Summer, 124
23. Winter Woods, Snow and Rock, 127

Walls, Fences, and Roads

24. Stone Wall, 132
25. Split Wooden Fence, 135
26. Wet Road in Springtime, 138

Problems and How to Correct Them, 143

Adding New Elements, 143
Correcting Small Details, 143
Altering Foregrounds, 145
Altering Skies, 149

Bibliography, 156
Index, 157

FOREWORD

I first met Arthur J. Barbour while he was a student at the Newark School of Fine and Industrial Art. I was the school's director at the time, and Barbour, having served in the Navy during World War II, was at the school under the G.I. Bill.

In those days all the students had to take a General Art Course for the first year, but Barbour soon discovered he had an affinity for watercolor and became one of the outstanding students. Completing the three-year Day Course, Barbour returned to his study of watercolor for a period of two years at the Evening School.

After a few years in the art field doing various jobs, he settled down to doing illustration, specializing in watercolor. His work has appeared in several issues of the *Ford Times* and *Woman's Day*, and he has done a series of landmarks in America for the Equitable Life Assurance Society as well as several Christmas card designs for the American Artists Group Collection.

In 1970 Barbour's work was reproduced on the Watercolor Page of *American Artist* and in 1972 the same magazine published two articles on his work demonstrating the combination of acrylics and collage. He has been experimenting for the past few years with the latter medium as a means of obtaining textures that are not possible with pure watercolor. Step-by-step demonstrations of

Barbour's new works were published in the Watson-Guptill books *Acrylic Watercolor Painting* and *Complete Guide to Acrylic Painting* both by Wendon Blake.

While Barbour was busy with various commissions, he was also exhibiting his paintings — winning over fifty awards since 1961. Included in these prizes were awards from the Allied Artists of America, the Painters in Casein Society, the New Jersey Watercolor Society, the Salmagundi Club, the Montclair (N.J.) Art Museum Annual, and three Awards of Excellence from the Marietta (Ohio) College Mainstream's 1969, 1970, and 1971 exhibitions, as well as the Purchase Award in 1971.

Along with painting for these exhibitions and his regular assignments, Barbour found time to do a series of watercolors and drawings for the U.S. Navy Department. They depicted the Navy and Marines in action aboard the U.S.S. *Ogden LPD-5*; at Guantanamo Bay, Cuba; and the homecoming from Vietnam of the aircraft carrier *Franklin D. Roosevelt*.

With this impressive background, Barbour proceeded to write his first book *Painting Buildings in Watercolor*, published by Watson-Guptill in 1973. Profusely illustrated in color, with some step-by-step demonstrations that have as many as

fifteen steps, the book represents Barbour's twenty-seven years of thinking, studying, and technical knowledge.

With his first book so enthusiastically received, Barbour wrote this book, *Painting the Seasons in Watercolor*. Its opening chapter gives practical advice, listing recommended colors, with a paragraph on each, describing how it looks, how it handles, how it behaves in mixing, mixtures wherein the colors are especially effective, and subjects that lend themselves to special colors. Various brushes and tools are described, with photographs of the effect they produce. A list of accessories for studio and outdoor painting and tips on composition conclude the chapter.

Barbour then gets to the grist of the book. He paints spring with its fresh green grass coming through the brown earth, contrasting with the grayed, washed-out grass that has survived the winter snow. Then comes the summer scene with its verdant foliage where everything appears to be a mass of green. In such subjects Barbour shows how warm and cool greens must be sought and their yellows and blues forced, if necessary, to define them.

With the fall season, almost the opposite holds true as restraint must be used to modify the riot of color. Here the author shows the importance of using various grays to act as a foil for the bright colors. But it is in the painting of a winter subject that Barbour excells — and he imparts his vast knowledge unstintingly. Far more is needed than blue-violet shadows to make a snow scene, and he again demonstrates the use of various grays to create a distinctive quality in a winter subject. He shows how trees, whose local color would be brown or deep gray, change in contrast with the white of the snow.

Most helpful to both the novice and the advanced student are the demonstrations of the individual elements that make up the subject in the different seasons. Trees, bushes, brooks, rocks, and roads are just some of the elements illustrated.

It has been an extreme pleasure for me to have had the gratifying experience of seeing Arthur Barbour's development from a student to one of our outstanding watercolorists, and to know that he, in turn, has unselfishly passed his accumulated knowledge on to another generation of students.

Henry Gasser
Director of the Newark School
of Fine and Industrial Art
1946–1954

INTRODUCTION

Painting the Seasons in Watercolor is designed to give you a step-by-step progression of knowledge in a wide range of tools and methods used by many of today's contemporary artists. The chapters take you from a simple philosophy of mixing colors, plus the use of black India ink, to a special section in which I talk about and explain composition—picture elements and their arrangement, color schemes, techniques, patterns and textures, and how they function in a successful painting. Then a series of steps shows how to render trees, bushes, water, snow, ice, fog, mist, rocks, mountains, walls, and roads. All are fully explained. There are twelve major demonstrations — eight with all the steps in full color and four with nine to eleven steps in black and white and the finals shown again in color. These paintings were carefully designed for the purpose of putting this book together on the seasons so that all the complex subject matter and the treatment of that subject matter are amply covered.

All the demonstrations were photographed as they were painted. They are "happenings" in the truest sense of the word, showing all the artist's tricks, all the thinking, all the necessary changing, correcting, and how to do it that lead to the design, development, and execution of a mature watercolor painting.

The demonstrations, made up of progressive steps, are filled with the knowledge of twenty-seven years of painting. Nothing is withheld or kept secret. All that I know I unfold with the ardent hope that this voyage into the world of watercolor painting will be a rewarding adventure.

You will learn in the 155 black and white steps the mechanics of handling various brushes, friskets, masking tape, cardboard squeegees, crumpled paper, and sponges. All these tools will be explained — which ones to use and how to use them in applying color to the paper with a variety of interesting skills and techniques.

In the full-color demonstrations you'll be transferred into the aquarelle world of brilliant color, varying moods, sunlight, and other lighting effects. You will learn how to run washes, paint drybrush, paint wet-in-wet, stipple, spatter, scrub out, lift out, sponge out, change and alter disappointing areas or passages, and then repaint them in a more pleasing arrangement.

You will be taught firsthand how to paint a roadside bursting with spring growth after a shower, a moss-covered stream in summer, a pond in autumn, a woods before winter, a mountain in snow.

Then a chapter in the back of the book explains more fully how to make corrections and counteract errors in the process of painting and also how to make changes after a painting is finished.

I think this book will be a considerable asset to anyone, either the beginner or the advanced student. It will help you over the many hardships that can befall an aspiring watercolorist, and will ultimately lead you to success.

TOOLS AND TECHNIQUES

In this chapter, we'll quickly review the basic watercolor painting materials and techniques. Of course, the tools that an artist uses will vary over the years from painting to painting; you will evolve your own style, discarding some tools and adding others. So consider this a starting point from which to build your own repertoire of materials and techniques.

Paper

Paper to the watercolorist is a foremost consideration; it is the atmosphere in which a painting breathes. The watercolorist talks paper, paper, and paper, because the paper is the vehicle upon which the pigments function — it is like a jewel, reflecting the light through the transparent colors to delight the viewer's eye.

So you can see that it's of great importance to select a paper of high quality, a paper designed to do the job in every instance. The paper must be made in several surfaces and weights so that you can make a choice and ensure clarity of statement for the particular effect or mood you want to create.

The difference in paper surfaces has a lot to do with how a wash behaves when it's applied to the surface, how it spreads into the wet surface, how it settles down into the half-wet surface, and how it looks when completely dry. Even though the texture of each paper varies, the same texture in a different weight paper also varies, and will therefore behave differently. These differences, when studied and investigated, will be beneficial to the artist in selecting the right paper for the right job.

So be sure to experience and study these results firsthand.

Watercolor paper comes mainly in three different surfaces — rough, hot-pressed, and cold-pressed.

Rough. Rough paper has an uneven, granular surface that diffuses the light reflections and softens the brilliance of the color. Sedimentation of the pigment on rough paper is not nearly so noticeable as on smoother paper, but when it combines with the natural texture of the paper, it lends its own irregular design to the surface, adding excitement to the wash areas. Because of its natural, coarse texture, it affords an extremely good surface for drybrush.

Hot-Pressed. The opposite of rough paper is hot-pressed paper. This paper has little texture. Washes alone on hot-pressed paper give some granular effect, plus a very soft, airy effect as they swim, intermix, and settle gently on the smooth surface.

The smooth hot-pressed paper reflects the light at a more direct angle — straight back into the eye. This aids greatly in the brilliance of the color. It is the light reflecting back off the white paper and through the transparent colors that lends that soft, luminous glow and the delicate hues to watercolor paintings.

Cold-Pressed. Next comes cold-pressed paper. This is the paper that I have felt more compatible with, and favorable toward using, for the last few years. To me, this paper combines the best qualities of rough and hot-pressed papers — it's not too smooth and it's not too rough. It's somewhere in

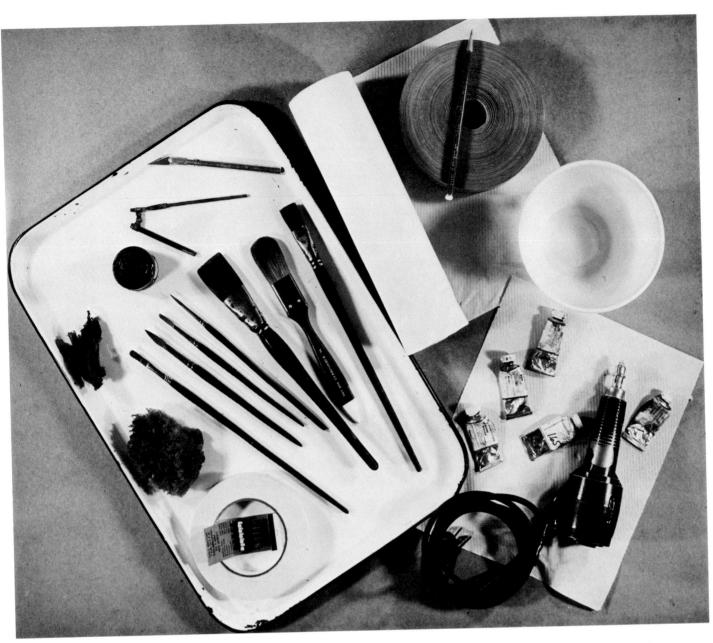

Overview of Materials. *From left to right: a butcher's tray for my palette containing a roll of masking tape, a matchbook, pieces of natural sponge, a flat sabeline brush, round ferrule red sabeline brushes of various sizes, a 1¼" flat brush, a 1" flat round brush, and a ¾" flat red sable brush, as well as a jar of black India ink, a fixative sprayer, and an X-Acto knife; a roll of carton-sealing tape; a No. 2 pencil; paper toweling; a water container; tubes of watercolors; and an electric eraser.*

the middle of the two in textural surface; it affords good color brilliance; its surface is textured enough for a decent drybrush effect; and warm and cool colors settle into the surface with a beautiful, scintillating design.

Paper Weights and Sizes. Watercolor paper comes in different weights and is expressed in pounds per ream of a specified size, with 500 sheets constituting one ream. For example, a 300 lb 22" x 30" (55.9 x 96.2 cm) sheet of paper means 500 sheets of that particular paper weigh 300 lb. For 140 lb paper 22" x 30", a ream weighs 140 lb.

The standard imperial-size sheet is 22" x 30". The double elephant size is 25½" x 40" (64.8 x 101.6 cm) and comes in 260 lb rough and cold-pressed surfaces. This large-size paper is the one I usually go to when working with acrylics in a transparent or semitransparent manner.

There are some new Arches sizes now available on the market: first, a roll of paper equal to 140 lb cold-pressed that is 43½" wide (110.5 cm) and 20 yards long (181.9 m), with no deckle; second, a 29½" x 41" (74.9 x 104.1 cm) sheet equal to 300 lb paper in rough only; and, third, a 400 lb handmade imperial-size sheet 22" x 30" in both rough and cold-pressed surfaces.

I used the 300 lb cold-pressed Arches paper quite extensively in the demonstrations throughout this book. I also did some demonstrations on Arches paper commercially mounted on heavy cardboard — Arches watercolor board. This is an exceptionally handy board for that quick, impulsive watercolor when there's no time for stretching. Its stiff backing but light weight make it readily accessible and easy to handle when painting outdoors.

It has always been my philosophy, and I have told students in the past, that if the budget will not permit both the best of paper and the best of paint, by all means put the money into the paper. A cheaply ground pigment color will always give the better performance on a good paper, and the color's performance will always be in proportion to the quality of the paper.

Colors

Pigment colors are finely ground granular particles that lie on top of the paper and adhere to it with gum arabic. Dye colors, on the other hand, are not finely ground particles, but organic and inorganic liquids that penetrate and stain the very fiber of the paper.

Rough Paper.

Hot-Pressed Paper.

Cold-Pressed Paper.

Pigment colors can be sponged off the paper surface rather easily, while dye colors are extremely difficult to remove. A percentage of the stain is always left there and has to be considered as part of the color that is repainted.

Earth colors such as raw sienna, raw umber, cobalt blue, ultramarine blue, and burnt sienna are pigment colors made from natural deposits of ores and minerals. A typical dye color would be alizarin crimson or sap green.

Here is a list of the colors that I have used extensively over the years. Though all may not be on my palette in the demonstrations in this book, they are part of my palette and are good colors, and you should consider including them in your palette. These colors come in tubes and are moist and ready to work with.

They are burnt sienna, burnt umber, raw sienna, raw umber, cobalt blue, ultramarine blue, permanent blue, sap green, olive green, cadmium orange, cadmium yellow, cadmium red, Winsor red, and alizarin crimson, as well as black India ink (Higgins). Here is a brief description of the colors and the way they behave when I use them. They should be observed and experimented with, and their characteristics imbedded in your memory file. Choice of colors is very much a personal thing, and you will find that as time goes by you will develop your own palette.

Burnt Sienna. Very much a favorite of mine. Its rich, rust-brown hue is beautiful to mix grays with; add it in varying quantities to different hues of blue paint. It will be a warmer gray if burnt sienna dominates the mixture and a cooler gray if the blue dominates. (Gray mixtures also vary according to the blue color that is used. We'll go into this a little more completely in the later section on Mixing Shadow Tones.) Burnt sienna is a great color to squish into solid areas of green foliage to break up the monotony of the green and to create color variety. I also use it for rust stains on boats, old shacks, and old, pitted, stained reinforced concrete.

Burnt Umber. Deeper in value and not as brilliant as burnt sienna. Burnt umber, mixed with cobalt, ultramarine, or permanent blue, gives a lower-key, subtler hue to gray mixtures. For instance, burnt umber mixed with cobalt blue produces a silvery gray, while burnt umber mixed with ultramarine blue produces a more transparent, granular effect. Investigate and study these mixtures until they become part of your painting vocabulary. I use this color in skies for silvery gray clouds and sil-

very early morning water in still lakes and ponds.

Raw Sienna. A yellowish, tannish, golden color, a little cooler and more transparent than yellow ochre. It gives a soft, greenish hue when it's mixed with blue, and a little touch of sap green in this mixture will give you a nice spring green that's not too sharp. I use various mixtures of these colors for practically all my greens. You can use raw sienna as a sky wash, either by itself or mixed with such warm colors as burnt sienna and cadmium red. You can also use it for sunlit shadows and light reflected into the shadow side of white objects, such as underneath building soffits.

Raw Umber. A rather muted, yellowish-brown hue, a little cooler than burnt umber. It also creates greenish-blue hues when it's mixed with blue. It can be used in sky washes, foliage, and foregrounds; and it makes a good, low-keyed green for grass when it's mixed with sap green. It's good for modifying shrub, brush, and scrub areas.

Cobalt Blue. A soft, velvety blue with a tinge of green that mixes well with earth colors. I use this 75 percent of the time in sky washes, sometimes mixed with permanent blue to give a greenish cast, but usually by itself. Mixed with cadmium red, it produces a beautiful bluish-purple color for cast shadows on white buildings. It's also good for painting distant mountain ranges.

Ultramarine Blue. A purplish blue, more grainy than cobalt, with a sharper hue. Mixed with burnt sienna, it gives a lovely granular effect when it settles onto the paper surface in wet washes. It can be used in sky washes, cast shadows, and purple mountains, and it mixes well with all colors. It's also very good for painting ocean waves or various sea effects.

Permanent Blue. A rich blue that mixes well with burnt sienna, burnt umber, and other umbers. I use it quite extensively in sky washes, sometimes mixed with cobalt blue. It also mixes well with sap green, olive green, and raw sienna for foliage colors.

Sap Green. A slightly yellowish-green dye color that stains the paper. It mixes well with earth colors, making beautiful greens when mixed with raw sienna and blue or simply with raw sienna or raw umber. I depend heavily on sap green, although it's not as lightfast as more permanent colors.

Olive Green. A manufactured mixture of raw sien-

na and Winsor green, its hue is, as its name suggests, an olive color. It's good for low-keyed greens in spring and muted greens in winter and fall. It's an all-around good, controllable green and mixes well with cobalt blue, permanent blue, and ultramarine blue for deep, lush greens.

Cadmium Orange. A very warm orange that you should use quite sparingly. It's like all the cadmiums—rather opaque. I use it in about one out of ten paintings, and then I use it instinctively rather than deliberately. In landscapes—in foliage, buildings, and foregrounds—it gives a lovely, warm summer-evening glow, like that of sunlight on red cedars near the end of day. It remains quite opaque when it's mixed with other colors.

Cadmium Yellow. A high-intensity yellow just verging on orange and also quite opaque. You can use it by itself for brilliant spots of sunlit color, such as those found on clothing, mixed with green for spring grass, and mixed with black watercolor for a beautiful, low-key olive green.

Cadmium Red. Also quite opaque, with a lightly orange cast. I often use it mixed with other colors, such as raw sienna and burnt sienna, as a pale sky wash, before I introduce stronger mixtures of gray and other colors. Sometimes I use it in foregrounds for broken patches of sandy earth you see through clumps of grass.

Winsor Red. A "red" red, ever so slightly verging on the purple side. It can be used in skies for underpainting of warmer colors, especially when mixed with burnt sienna and raw sienna. It also mixes well with permanent, ultramarine, or cobalt blue for a good strong purple, which can be used to render mountain ranges very well.

Alizarin Crimson. A strong wine color. Its red cast overpowers any mixture. I seldom use it, unless I want a very strong purplish-red accent, but I have used it on occasion as a light wash, mixed with cobalt blue, at the bottom of a sky for atmospheric distance.

Black India Ink. I sometimes use this heavily, and on other occasions, I hardly use it at all, depending on the degree of texture and definition I'm trying to achieve. I first started using India ink for pine trees and other foliage, and lately I've been using it to define shadows and textures on buildings. I usually mix it with other colors or add it to the wet washes of other colors. I prefer it to black watercolor paint because it doesn't spread too far when mixed into wet washes. The ink usually goes into a wet wash, spreads nicely to make a feathery edge, and, then, unlike black paint, it "grabs" the surface of the paper and stops spreading. When it's mixed with other colors in wet washes, it also stops colors from spreading too much.

Mixing Shadow Tones

All my grays are made by mixing colors; there is no commercial gray on my palette. The diagram shows the main colors I use for grays. They are all mixed from browns and blues. Any brown or blue

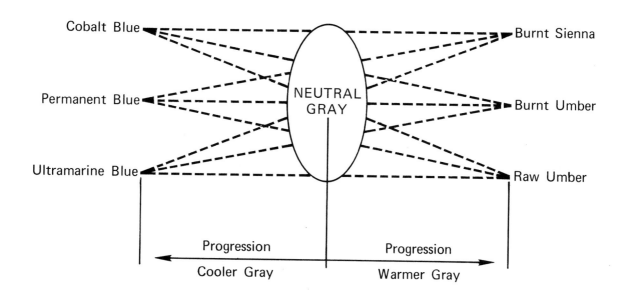

Color-Mixing Diagram for Shadow Tones.

mixed in proper proportion will give a neutral gray. Push the mixture toward the blues and the gray becomes cooler; push the mixture toward brown and the gray becomes warmer. I choose one of the blue-brown combinations to create shadow tones for such subjects as clouds, mountains, trees, and foreground.

To learn how to mix grays, let's paint a simple ball. Draw a circle about 3" (7.62 cm) in diameter. Use a brush to wet the area with clear water. Now paint it a solid sap green. Mix ultramarine blue and burnt sienna to make a deep mixture of neutral gray. Put some sap green in the mixture, and this will give you a dark gray-green. You will now have a good shadow tone.

You can make it a cooler or warmer green depending on how you mix your gray. If you emphasize the burnt sienna side of the mixture, you will have a warm green. If you emphasize the ultramarine blue side of the mixture, you will have a cool green. Paint your gray into one side of the wet circle, and you should have a good shadow tone.

Try the same thing for red. Mix burnt sienna with one of the blues—cobalt blue, permanent blue, or ultramarine blue. Or mix ultramarine blue with one of the browns—burnt sienna, burnt umber, or raw umber. Each gray mixture will act differently, depending on your selection of blue or brown.

Paint a flat red circle with Winsor red. Make a gray mixture of burnt umber and cobalt blue and mix in some Winsor red. You should have a thick, deep gray-red for a shadow tone. Paint this into one side of the wet red circle as a shadow to make it look round.

This formula for mixing all shadow tones will work for all colors and is a simple, excellent guide, since the shadow tone can be controlled for intensity of color as well as for warmth and coolness.

This brief description of color mixing is a good basis for the understanding and application of color. It's not the final story for color mixing, but a springboard you can take off from in different directions.

Brushes

The brushes I prefer to use are mostly all the cheaper sabelines instead of pure red sable. I like these brushes because they take a good amount of abuse. I spare my brushes little: they are pushed, twisted, and dragged into and over the paper's

Brush Techniques: Round

Wash on a Dry Surface (Top) and Drybrush (Bottom). *Here you can see a brush fairly loaded with color and the various strokes it can make. The top swatches are painted directly on dry paper using the point of the brush. On the bottom is the drybrush effect: I hold the brush almost flat and drag it across the paper. The paint only adheres to the top of the little bumps and the shallows of the paper stay white. The pointed tip can make fine lines in either solid color or drybrush according to how fast you move the brush and how much water and paint are in the hairs.*

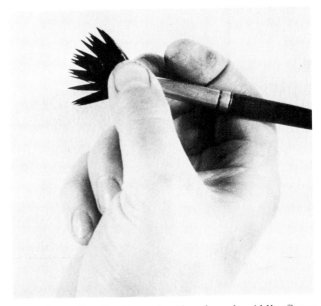

Fanned-out Brush. *Here the thumb and middle finger squeeze the brush at the base of the ferrule to fan or flare out the hairs into many little brushes.*

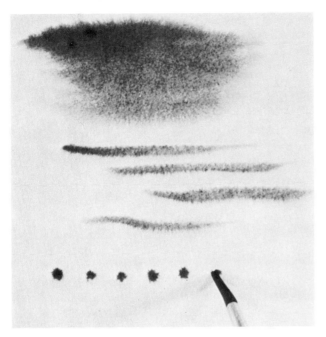

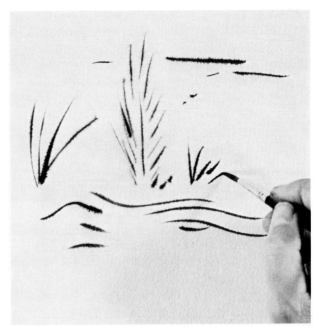

Wash on a Wet Surface. *Here we see how paint behaves when it's introduced into a wet surface. The pigment spreads and settles into the textured web of the paper. As the paper loses moisture and dries somewhat, better control of the pigment can be achieved and finer strokes can be made more easily. Fairly thick color dots of various sizes can be made while the paper is still moist. Be sure not to have more water in the brush than the paper contains to avoid feedback. Remember that the washes dry almost one-third lighter than when applied wet.*

India Ink Applied with a No. 3 Brush to a Damp Surface. *Dip the brush into the ink and palette it out on a piece of cardboard to the right flow consistency. Stroke fine lines into the damp surface of the paper; notice that the ink runs off or blurs slightly and then stops. With a little practice, good control can be obtained. We will use ink mixed with color extensively throughout this book.*

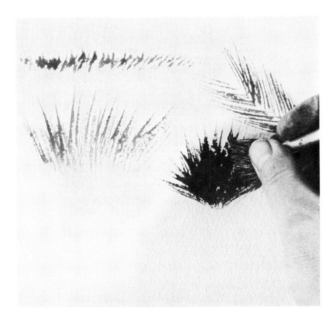

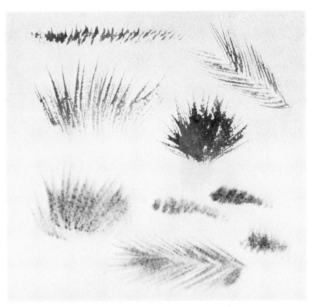

Using a Fanned-out Brush. *Various strokes can be made for tufts of grass to palm leaves. The approach here is directly on dry paper.*

Fanned-out Brushstrokes on a Dry (Top) and a Wet (Bottom) Surface. *Note the soft, velvety look as the pigment spreads and seeps into the wet paper. After the paper is completely dry, the simple strokes will have an airy effect and once again dry much lighter.*

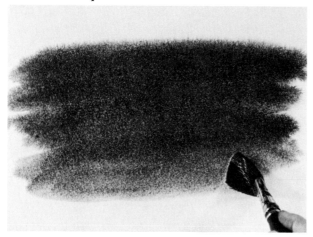

Large Wet Wash Laid in with a 1¼" Sabeline. Here the loaded flat brush is covering a lot of ground on dry paper. A large wet wash is accomplished with less struggle than with a round brush of the same capacity. Again, after the washes dry, the values will appear much lighter.

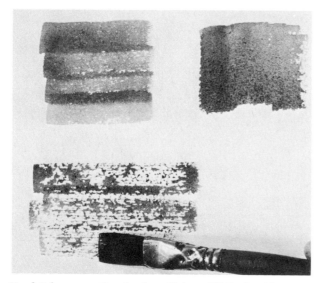

Hard Edges on a Dry Surface, Using a ¾" Red Sable. Here the flat brush is used to apply color to dry paper. Notice in the first swatch that this brush produces overlaying edges because of its square shape. The second swatch shows a fairly flat, direct wash can be manipulated easily. The third swatch shows its easy approach to drybrush.

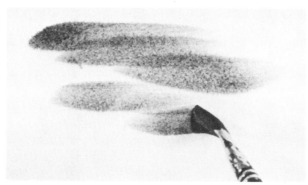

Blurred Edges on a Wet Surface, Using a ¾" Red Sable. Here we see the slick, smooth application of the flat brush when it is applied to a wet surface.

surface. Under these conditions I find the sabelines hold up much longer than the pure red sable brush.

Round Brushes. In a round brush the hairs are fixed into one end of a cylindrical metal holder (the ferrule), so the hairs form a cylindrical shape and come to a point. Round sable brushes are used in various passages throughout a painting, but not usually in large, bold washes such as skies or other large areas. I use #3, #6, and #10 round brushes in the demonstrations in this book.

Flat Brushes. In a flat brush the end of the metal ferrule that holds the wooden or plastic handle is round, while the end that holds the hairs is flattened out. Thus the hairs form a rectangle with a squared-off tip. Flat brushes are especially handy for applying large washes.

In the last few years the ¾" flat red sable had begun to play a major role in the rendering of my watercolors. It has the ability to slip colors into semiwet washes with an ease that far surpasses that of the conventional round brush.

Other Brushes. I have a 1" flat round brush that I was once asked to test by an artist's materials manufacturer, but it was never marketed. It's a pity, because I really love that brush. It is constructed in the same manner as a regular flat brush except that the painting edge is rounded across the width of the brush. It is very similar in application and results to the 1¼" flat brush that I use for washes, except that it lays paint on a little softer because it does not have the square edges to cause drag like a regular flat brush.

Other Tools for Applying Paint

Of course, paint can be applied to the surface with tools other than brushes. Some of the tools that I find most useful are natural sponges, a piece of folded paper such as a matchbook cover, and even a crumpled piece of paper.

Natural Sponges. I use natural sponges for laying in washes and for stippling, and they play a large part as a painting tool in most of the demonstrations that follow. Natural sponges are softer and easier on the surface of the paper than artificial sponges. Plastic sponges seem to scratch or scar the paper when used extensively in sponging areas out. The real sponge has a variety of holes and shapes, and when used as a painting tool, can imprint a variety of textures and designs on an area

Stippling Techniques

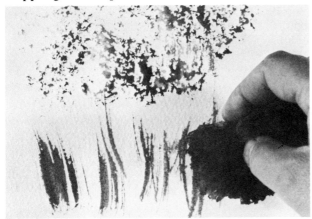

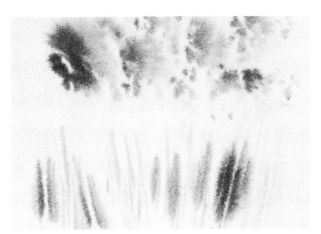

Natural Sponge on a Dry Surface. *Here is the sponge treatment on dry paper. The upper design is achieved simply by pressing the sponge lightly into the paper. The lower portion is achieved by using the sponge in short vertical strokes similar to those of a brush.*

Natural Sponge on a Damp Surface. *Here the same simple treatment of gently pressing the sponge into the paper is applied on a damp surface. Note the diffused, elusive design caused by the soft spreading of the pigment.*

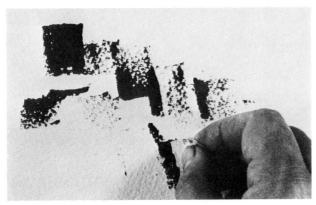

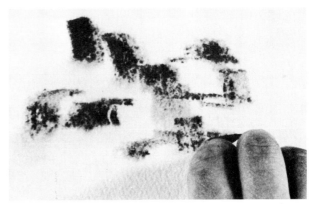

Scraping Color into a Dry Surface with a Folded Matchbook Cover. *Fold the cardboard into a small rectangle about 1" x ¾" (25.4 x 19 mm). Scrape up colors on an edge and press and drag the cardboard on the dry paper. The result is an uneven mixture of color transference that dances on the paper in a drybrush effect.*

Scraping Color into a Damp Surface with a Folded Matchbook Cover. *Here the same technique is worked into a damp surface. The colors diffuse and blend unevenly, giving a scintillating effect.*

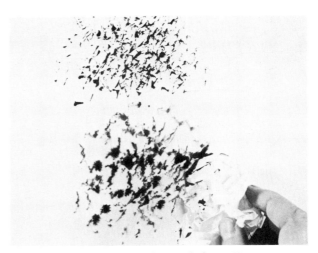

Imprints Squished into a Moist Paper Surface with a Folded Matchbook Cover. *Here several imprints depicting rocks, bushes, trees, and pines are squished into a moist surface. This technique can give rewarding results when harnessed into a controlled design.*

The Crumpled Paper Printing Technique. *You can crumple in different degrees any sort of paper — white bond paper, brown paper bags, newspaper — and dip it into a thick mixture of paint. Then stipple it on dry paper (top) or damp paper (bottom) to see the intriguing results.*

that otherwise would be a difficult passage to paint.

Cardboard or Paper Squeegee. A folded matchbook cover, or any piece of cardboard or folded paper, is an excellent tool to squeegee pure color onto the paper. Fold the cardboard so that it's 1″ x 2″ (2.5 x 5.1 cm) to make it sturdy, and scoop up undiluted paint or mixtures of pure paint straight from the tube. Then use it to squeeze paint into wet washes and to apply paint directly onto dry paper.

Crumpled Paper. A piece of crumpled paper can be used to give a change of pace in texture, which is needed to enhance a painting and keep it alive. The texture produced is particularly good for laying in the suggestion of foliage, piles of stone, a stone wall, or rubble in a random arrangement, which can then be further developed and sharpened up with a brush.

Lift-out Tools

Painting is not only applying paint to the surface, but selectively removing it. Paint can be erased or lifted off to correct and obtain special effects, such as sharpening detail and highlighting areas. I find plastic erasers, an electric eraser, paintbrush handles, and an X-Acto knife blade the most helpful tools here.

Plastic Eraser. Other erasers, such as art gum or kneaded, can be used, but the plastic eraser works by far the best for me. It is probably the least used of any of the tools mentioned here, but when an occasion arises, I'm glad to know that a simple maneuver can sometimes save an important passage. Sometimes an edge can be picked up or lightened, or a whole area lightened somewhat when nothing else will make the painting work. Just hold the eraser in your hand, place it to the area that needs correcting, and then merely . . . rub your head off.

Electric Eraser. This is a commercial tool used extensively by draftsmen and architects. I acquired one from an old friend, and find it quite handy in erasing small highlights or small areas that need correction. I rapidly burnish the paper, leaving a smooth surface that will take a rather fair wash. But be careful, as this tool can tear or wear through a lightweight paper. The biggest caution of all is not to use it extensively, as erasures with it may become too obvious and can offend the eye.

Lift-out Techniques

A Plastic Eraser.

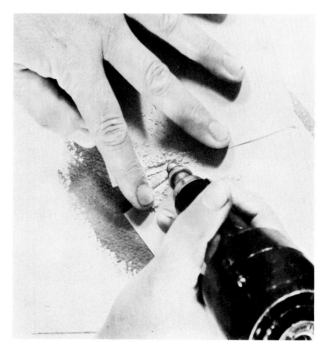

Using Sheets of Paper as Friskets While Erasing an Area with an Electric Eraser. At times I cut small desired shapes out of heavy paper in order to alter the design of an area with the electric eraser.

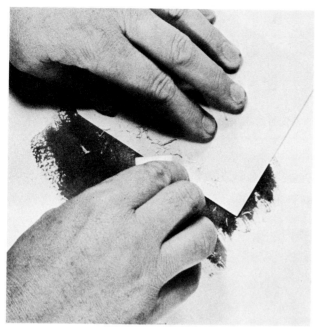

Using a Piece of Paper as a Frisket While Erasing an Area with a Plastic Eraser. *A change can be made safely by using a plastic eraser in this manner and rubbing hard.*

The Finished Result. *Use this technique mostly on small areas, for if the value is lightened a great deal, it usually shows that the area has been unnaturally disturbed.*

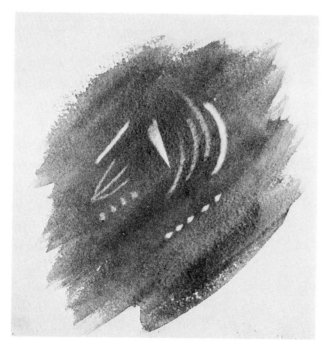

The Finished Result. *See how the eraser burnishes through to the white of the paper in varying degrees. Paper shields were used to achieve the pointed shapes. The other marks were made by merely directing the eraser freely by hand.*

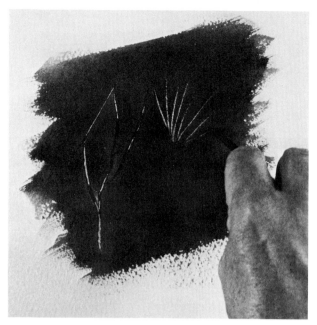

Using a Paintbrush Handle to Scrape out Lines in a Moist Surface. While the wash is still damp, press the end of the handle into the moist surface and stroke with pressure. This will crush the surface and squeeze the moist pigment out of the paper, leaving a light line. If the wash is too wet, the crushed surface of the paper will act as a channel and lead more pigment back into it, making a darker mark as in the first image. This can be used for shrubs, bushes, clapboard, or any other object with dark lines. The second image was made by the brush handle when the content of the moisture in the wash was just right for making lighter lines.

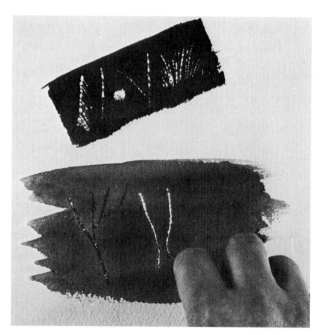

Using an X-Acto Knife to Scrape Color off a Damp Surface. The top wash is dry; note how the blade scrapes the paper and color right off the surface. The wash below shows, first, the bleed-in of color if the wash is too wet and, second, the crisp strike-out when the wash is damp.

Paintbrush Handle. The back end of the brush, the handle, can be a quick tool to help develop highlights for branches or flashing lines when needed in a painting. When a wash is almost dry, take the handle of your brush and press the tip into the wash with a short, scraping motion. The pressure forces the moist pigment out of the paper, leaving a light line. This method is good for detailing foliage and accenting twigs and small trees.

Knife Blade. The sharp #11 blade of the X-Acto knife is a tool with many uses. Small areas of a picture can be scraped out and then erased with an electric eraser to smooth out the texture of the paper for the purpose of repainting the area. Sometimes I use it to scrape out a mark, using only the end of the knife blade. Don't overdo this effect; use it sparingly.

Other Equipment

Other accessories are needed to complete the watercolorist's array of materials—everything from tables and drawing boards to water containers and masking tape.

Tables. A good working surface is an old-fashioned white porcelain-topped kitchen table—hard to come by these days. Not only do I have my painting board on the table, but it affords loads of room to spread paint and mix washes on. Also, it can be washed off easily with a wet rag.

The table I work on is an old wooden office desk 3′ x 5′ (91.4 x 152.4 cm), which is very heavy and stable. I had the desk leveled because I work flat and I like my table to be perfectly flat. I only elevate the painting board as a last resort to help grade a wash or stop a large wash from creeping in the wrong direction.

Drawing Boards. I usually work on heavy, sturdy boards—some old drawing boards 31″ x 23″ (78.7 x 58.4 cm) by ¾″ (19 mm) thick or ¾″ plywood cut 32″ x 24″ (81.3 x 61 cm) for the imperial-size sheets. For the double elephant size, I cut the ¾″ plywood to 29″ x 42″ (73.7 x 106.7 cm), just the right size to take the 27″ x 40″ (68.6 x 101.7 cm) sheets. I really prefer the plywood boards over the drawing boards, since the latter tend to come apart from the moisture in the wet paper.

Palettes. A large enamel butcher's tray is perhaps the best palette. It affords a large working surface

– 13″ x 19″ (33 x 48.3 cm) – and since I have a rather poor system, or no system at all, for placing colors on the tray, I really have a great time spreading them around. I usually keep the browns and blues together for mixing grays. The other colors go anywhere.

Paint Boxes. For the first few years as a professional student I carried my few prize tools, brushes, paints, etc., around in a cardboard shoebox. Then I graduated to a metal fishing box. The tubes of watercolor fit easily in the upper divisions, along with razor and X-Acto knife blades, erasers, and matches. The larger bottom area can be used for brushes, sponges, pencils, India ink, paper towels, and masking tape.

Water Containers. Many foods today come in plastic containers, and some of these make terrific containers to hold your water for painting. Even a large bleach container with the top cut off provides a large opening that is easy to dip the brush into during the excitement of executing the painting.

Pencils. There is a wide selection of drawing pencils available, but I like a regular No. 2 writing pencil because it's dark enough yet soft enough not to mar the paper and it erases easily.

Fixative Sprayer. This tool is a simple version of an atomizer, and it's used to spray a fine mist of water over the painting surface. I use it to rewet large wash areas in order to avoid lifting the washes as I might if I used a regular brush. An illustration of the fixative sprayer appears on page 154 in the chapter on Problems and How to Correct Them.

Paper Towels. Paper towels are used for every phase of my work – for stretching the paper, cleaning the palette, wiping the brushes, stippling the paint, blotting and lightening sections of the painting, wiping out washes, and wiping my hands and the grime from my face.

Matchbooks. The matchbook comes in handy for squeegees, and I also use the matches to heat stubborn paint tube caps so they can be easily removed. Light the match and rotate the cap in the flame for a few seconds. Then, with a folded paper towel so you won't burn your fingers, remove the cap.

Masking Tape. Sometimes in a difficult maneuver I'll use regular masking tape to mask out areas or I'll cut the tape for masking out shapes. A passage can be isolated with tape and the area sponged out and repainted. This is fairly easy to do on a tough-surfaced paper like Arches, especially if I'm careful when I remove the tape so as not to pick up the surface of the watercolor paper.

How to Stretch Watercolor Paper

Draw a line 3/8″ (9.5 mm) to 1/2″ (12.7 mm) from the edge of the paper all the way around. Soak an imperial-size watercolor sheet 22″ x 30″ (55.9 x 76.2 mm) in moderate temperature water in the bathtub. While it is soaking for 15 to 20 minutes, cover the surface of your watercolor board – covering an area slightly less than the size of the watercolor sheet – with clean paper towels.

Now take a roll of carton-sealing tape – the type that requires water to wet the glue – and cut four strips the length of the board and four strips the width of the board.

Lift the paper gently out of the water by the edges and hold it over the tub to allow the excess water to run off. The paper has absorbed water while soaking and is perhaps 3/8″ to 1/2″ larger all the way around.

Now place the paper over the paper-toweled board. The watercolor paper should cover the paper towels completely so that only the bare board is visible around the edges. The paper towels give a good resilient feel to the watercolor paper and also keep the reverse side of the paper clean for a future painting if this one should fail to come off.

Use paper towels to dry about 2″ (5.1 cm) of the outer edge of the watercolor paper, all the way around, until it is dry to the touch.

Wet the water-soluble strips of tape. You can use a sponge or a regular tape machine, but I use a saucer or plate filled with water and drag the glue side of the paper across the water. Then squeeze the excess water off by running the tape once very quickly through your fingers. Place the wet tape onto the edge of the pencil line on the watercolor paper, and let the rest extend over and onto the wood section of the drawing board.

Now press the tape into the paper and onto the wood board. Press and rub the tape gently several times so it will adhere firmly to both the watercolor paper and the board.

For the past twenty years or so, the glue adhered sufficiently, and all that was necessary was to let the paper dry in a flat position overnight and it would be ready for use in the morning. But in the last few years the glue alone doesn't seem

to hold. Either there isn't enough glue, or it's just no good. So I use a staple gun and drive about ten staples on the length and about seven on the width through the tape and paper into the board. This always does the trick.

After leaving the paper to dry in a flat position for about six to eight hours, you can then draw, erase, and paint on it without having it buckle.

There's a good reason for stretching paper in the first place. The paper is thoroughly soaked in water and it swells to a larger size. It is soaking wet but it still lays flat. By taping and stapling it to a thick board, you trap it in its swollen state. When the paper dries, it cannot shrink smaller. It stays in the larger size, which is just about its maximum expansion. So when the paper is wet again during the painting process, it cannot swell and buckle, and you're able to paint washes on a smooth, flat surface.

Then when the painting is finished, you remove the staples with a small screwdriver or any other tool that you have on hand. Just run a razor blade along the edge of the watercolor paper to cut through the tape, and the painting is free.

Lighting Conditions

I work 95 percent of all my watercolors under artificial light. I use a combination of cool white and daylight fluorescent tubes. This gives off a light very close to the natural light outside.

I've worked this way for years and can see little difference when viewing my work outdoors or occasionally painting one in daylight outside. Also the majority of works in galleries and museums are viewed under artificial light.

Painting Outdoors

On-the-spot painting has always been a necessary evil that seems to destroy my every desire to execute that masterpiece. Kneeling or squatting down, kicking sand or dirt and stones into wet washes, combating bees, spiders, heat, mosquitoes, and the bleaching sun, I feel the overall discomfort of just suffering plain discomfort.

But nonetheless it is necessary to apprehend the goings-on of nature — the shifting light; trees reaching out and up toward the light; the swirling, changing skies in contrast to the earth scattered with scrub, grass, and pine; the stillness of mirrored ponds; the babble of running brooks. All this beauty — to the discomfort of the on-the-spot painter.

So I take along the closest things I can to imitate the comfortable working conditions of my studio: a folding card table, to which I attach a large beach umbrella to keep the sun and glare off the paper and from drying the washes too fast. I wear sunglasses to cut the glare from sand or snow. You won't have any trouble mixing colors if the glasses are a neutral tint.

Many students have trouble seeing the true depth of values that need to be translated to a white paper, especially when viewing a scene in living color. They are confused by the color and have trouble interpreting it in terms of values. So here's a hint that I feel is useful when working outdoors.

Carry a black and white Polaroid camera with you. This will show you the necessary translation of values. It will also help in selecting and organizing your composition. You'll be able to pull together the black and white values, simplifying all the confusion the eye sees while viewing the real thing. Pin the Polaroid snapshot to your working board. You will have the black and white values translated for you and all the true color in front of you. Now paint away.

Tips on Composition

Here are some of my ideas on what makes a good picture. They are not mine alone, because all artists work with the same compositional problems whether they paint realistically or abstractly. A picture works when all compositional elements are balanced properly.

Let's look at a blank sheet of paper that we are about to break up into special arrangements of shapes and areas. To cut a sheet in half with a dividing line would be boring; both sides would be the same. Divide it again in half the other way, and it's still boring. There are four equal shapes to look at.

Now break it into two different-size shapes and you have interest. The interest is better still with three different-size shapes. Let's call this major breakup of space the basic or simple composition. Remember, keep it interesting.

Next comes the design of the different elements that help weave the composition together. These should be thought of as being different in size and shape, yet carefully designed to have a relationship to each other and to the composition as a whole.

Then we develop the "pattern" of the composition — the lights and darks. Be sure to keep them

from being monotonous. For instance, maybe two-thirds of the composition will be in a deep value while one-third will be in light, or vice versa. Also the subtle darks and lights have to be considered in the overall dark area and likewise in the light area. Constantly vary them to keep them alive and interesting.

Finally comes the thinking on color. Besides different hues that have to be related, you must consider the warm and cool aspects. They must counteract and harmonize to keep excitement alive, always fighting boredom.

With all this going on, let's also consider textures of varying interests. Open areas with hardly any texture should be interplayed with soft, subtle textures of another area. One beautiful rasping texture should be played against the other two. This interplay of textures can thrill the eye.

So here we are with six intriguing elements that must be dealt with when creating a picture:

1. Basic or simple composition (large breakup of space)

2. Design (the integral parts or elements that hold the total composition together)

3. Pattern (arrangement of lights and darks throughout)

4. Color (different colors that must be related to each other)

5. Warm and cool (supporting good color harmony and contrast)

6. Texture (a change of surface appeal to the eye)

With this in mind, you can more easily judge what's lacking in a picture. Where does it fail? Are some of the above-mentioned concepts functioning properly, or are some repetitious and boring in size, shape, pattern, texture, and color? Are the warmth and coolness of colors balanced? Are they working against each other for variety?

Now you're ready to begin painting.

TREES

DEMONSTRATION 1
BARE SOFTWOOD TREE

Here's one approach to a tree without leaves. To paint this subject, study a number of trees without leaves in order to understand how a tree grows.

For this demonstration I'll use one color, burnt sienna, plus black India ink. I'll use the No. 6 and No. 3 round ferrule brushes, a butcher's tray for my palette, paper towels, and a container of water. I've soaked, stretched, and dried a sheet of 300 lb Arches cold-pressed paper.

I'll use the drybrush technique almost entirely in this demonstration. To begin, I sketch a tree with a heavy line. I use a heavy line on purpose so that the drawing won't get lost under dark or heavy washes as my painting proceeds. Keep this in mind in your own sketching. Remember to squeeze out a generous amount of paint when you're beginning a painting so that you won't run short as you work.

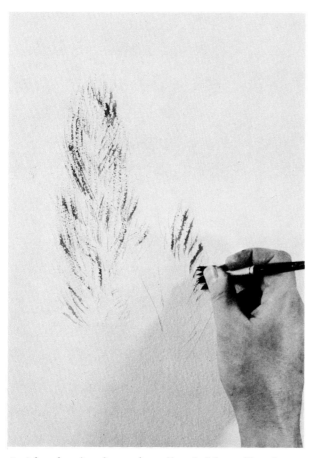

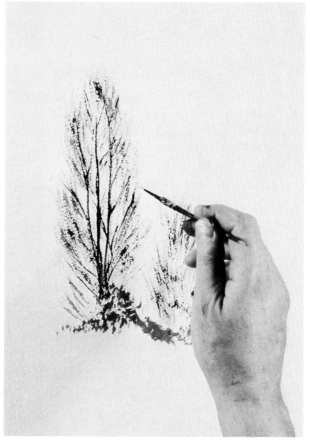

1. After drawing the tree's outline, I pick up diluted India ink and burnt sienna on the No. 6 round brush. I fan out the brush between the thumb and middle finger to produce the effect of many little brushes. I use short strokes to simulate tree branches on the dry paper.

2. I repeat this process until the desired tree shape is constructed. Then I use the No. 3 round brush with burnt sienna and slightly diluted black India ink to render the slender tree trunks and main branches.

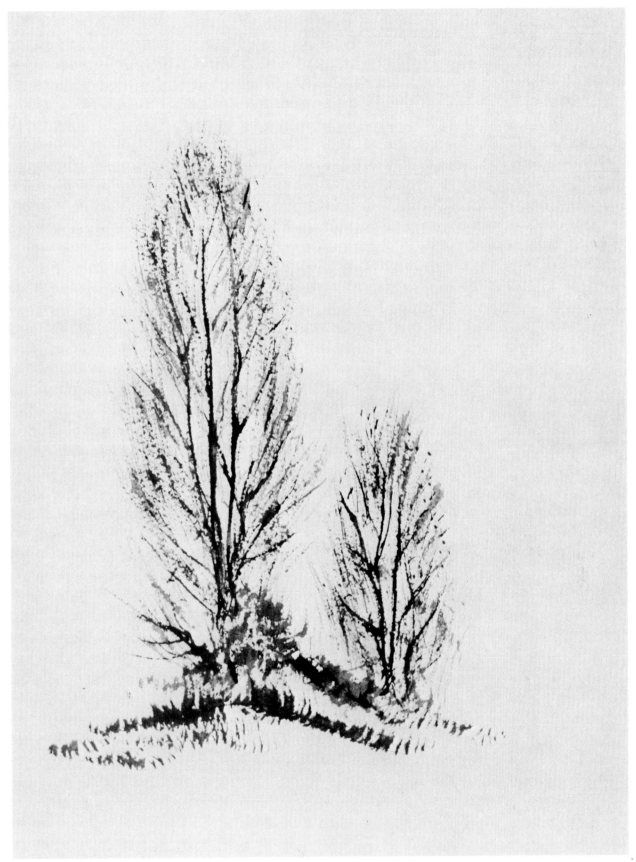

3. *I put in the simple foreground with the fanned-out brush, using the same mixtures. After placing in the branches of the smaller tree, I stipple a little with the tip of the brush for a change of texture.*

DEMONSTRATION 2
BARE HARDWOOD TREE

This rendering shows another tree with bare branches. For this demonstration I use both the wet-in-wet and semi-drybrush techniques. My palette consists of two colors, cobalt blue and burnt sienna, as well as black India ink. I'll use two brushes — a No. 6 and a No. 3 round ferrule — and a sheet of 300 lb Arches watercolor paper prepared as in the previous demonstration.

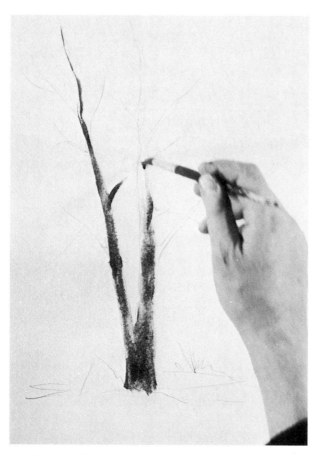

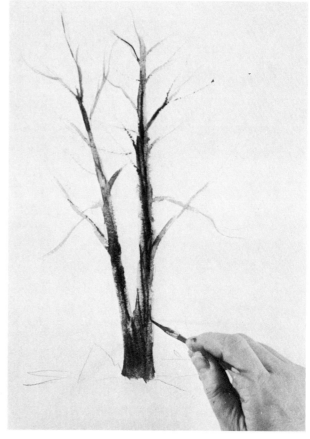

1. After sketching a bare tree in a country setting, I wet the main tree trunk with clean water. Using the same No. 6 brush, I paint in mixtures of cobalt blue and burnt sienna unevenly in mixtures of cool and warm color.

2. Still with the No. 6 brush, I drag out these mixtures for the main, heavier tree limbs. Then, using the No. 3 brush, I paint in mixtures of cobalt blue, burnt sienna, and black India ink for the texture of bark.

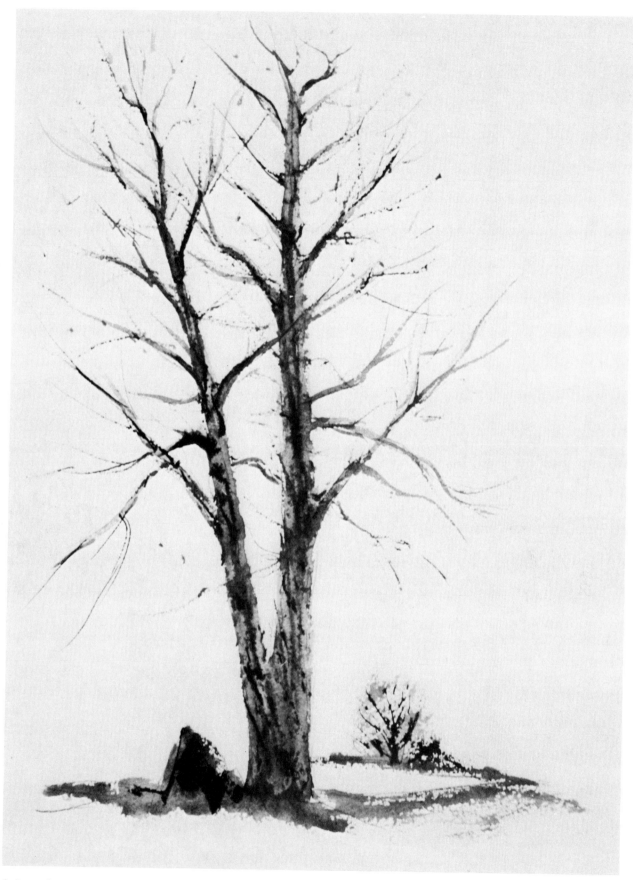

3. *I use the No. 3 brush with the same colors for the rest of the smaller branches and twigs in a semi-drybrush technique. I use both colors for brief descriptions of ground, rock, and the distant tree, touched here and there with black ink.*

DEMONSTRATION 3
LEAFED-OUT TREE

In this demonstration I use the sponge technique to its fullest. The colors I'll use are sap green, raw sienna, cobalt blue, and black India ink. I'll use natural sponges, No. 10 and No. 6 watercolor brushes, and a 300 lb rough sheet of Arches watercolor paper.

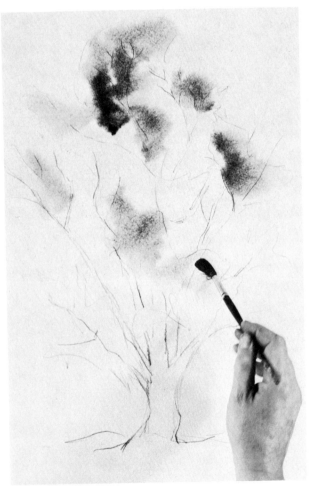

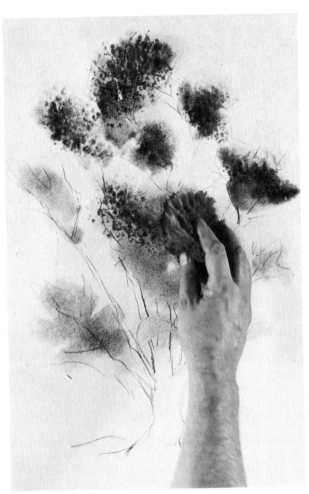

1. With a clean sponge, I wet the complete area with water. Using the No. 10 brush on the wet paper, I work in mixtures of sap green and raw sienna to create a yellow-green as an underpainting for the darker colors that come next.

2. I scoop up mixtures of cobalt blue, raw sienna, and sap green onto a sponge and stipple these into the moist paper for leafy textures.

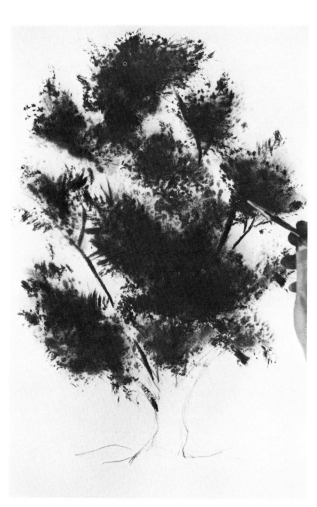

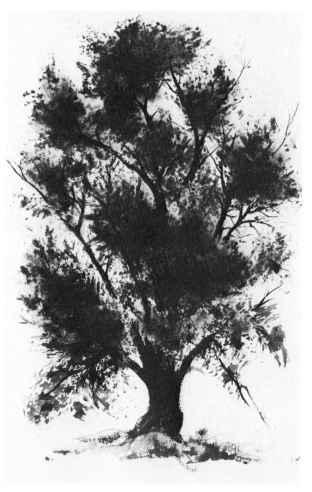

3. Still using the sponge, I develop the foliage further, using the same colors plus a light stippling of black India ink. Then with the No. 6 round brush, I use raw sienna and black ink to put in the branches. The paper is almost dry now.

4. Next, with the sponge, I stipple and squish a little texture, using raw sienna, cobalt blue, and ink, into the dry paper to complete the foliage. Then with the same colors and a No. 10 round brush, I paint in the trunk of the tree. I use a lighter tint of the same colors for the grass at the bottom of the trees.

DEMONSTRATION 4
PINE TREE COVERED WITH SNOW

The approach in this demonstration will be a combination of wet-in-wet at the beginning and drybrush to finish. My palette consists of olive green, burnt sienna, and permanent blue. I use only one brush for this demonstration, a No. 10 watercolor brush, on Arches rough watercolor board.

1. I first wet the entire area of tree and background with clean water and a sponge; then I paint a mixture of permanent blue and burnt sienna in the background around the tree in a wet, casual manner.

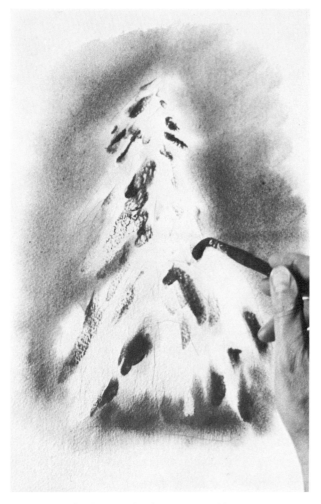

2. Next I paint in a wash of permanent blue and burnt sienna on the left side of the tree for shadow and form. Then I work mixtures of permanent blue, olive green, and burnt sienna into the tree area for pine branches under the snow.

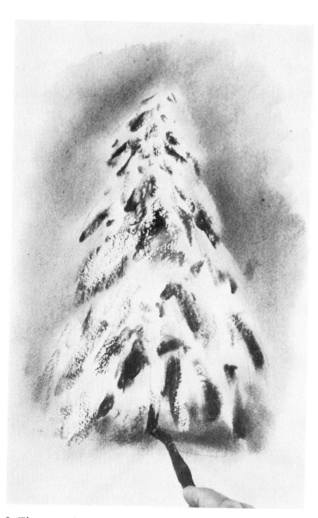

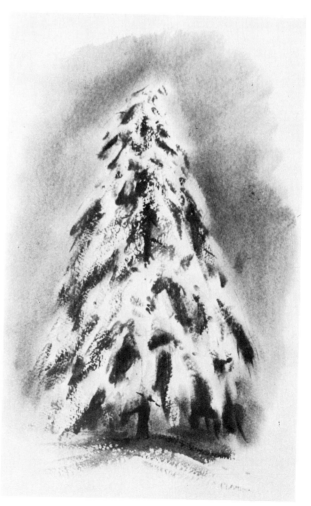

3. *The paper is somewhat dryer now, and the rest of the pine branches go in as drybrush with the same colors. I put the trunk at the base of the tree in, using permanent blue and burnt sienna.*

4. *I place in a suggestion of the tree trunk in the middle of the tree and fan the brush out to a flat edge to complete a few smaller branches. I use a stippled drybrush for more suggestion of pine texture through the snow. For the snow at the base of the tree, I paint in a few strokes of a cool blue, using permanent blue and burnt sienna.*

DEMONSTRATION 5
PINE TREE IN SUMMER

This demonstration shows how the wet-in-wet technique, by its very nature, helps to render the soft, fuzzy quality of the pine. The colors I'll use here are burnt sienna, sap green, permanent blue, and raw sienna, plus black India ink, and the tools are sponges and No. 10 and No. 6 round brushes. I stretch a sheet of Arches 300 lb rough paper on a ¾'' plywood board for this demonstration.

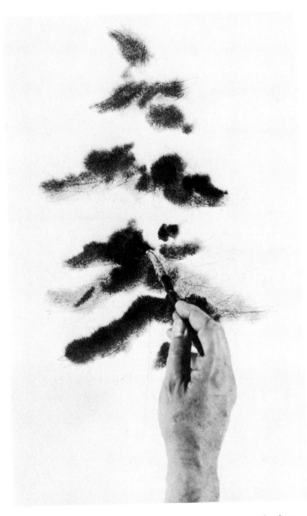

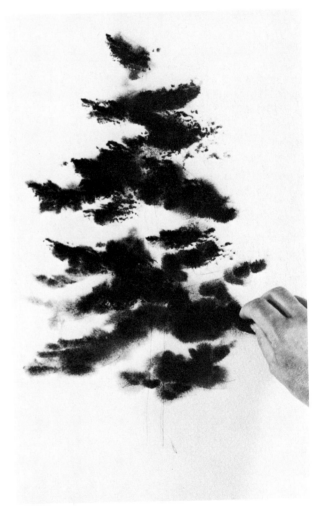

1. With a sponge, I thoroughly wet the paper with clean water. With the No. 10 round brush, I work in washes in the pattern and form of branches filled with pine clusters, using raw sienna, sap green, and a touch of permanent blue.

2. I continue with the same colors, only using more permanent blue, to nearly complete the design of the tree. Now as these washes settle into the paper and the moisture evaporates leaving the paper just damp, I take a sponge loaded with permanent blue, burnt sienna, and sap green and stipple in some texture. Again I lightly stipple with the same colors plus black ink in the damp pigment to further deepen and finish the pine rendering.

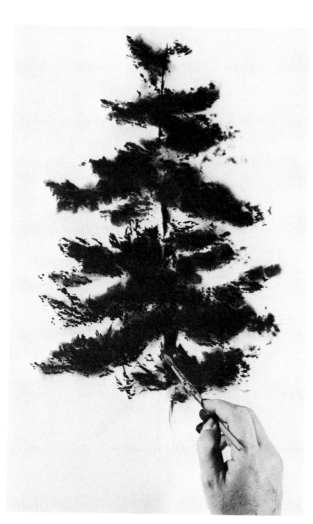

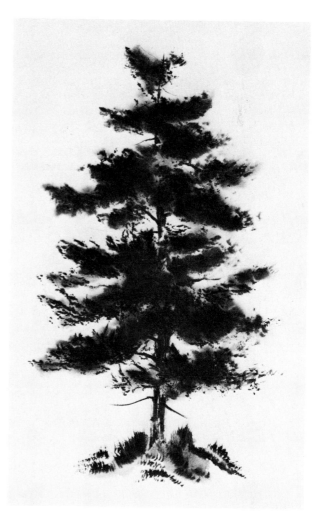

3. With the No. 6 round brush, I paint burnt sienna and black India ink into the nearly dry paper to start rendering the tree trunk.

4. I finish the tree trunk and use the same procedure to complete the tree branches. I paint in the ground and clumps of bark with a fanned-out No. 10 brush, using raw sienna, sap green, and India ink.

BIRCH IN SNOW

I designed this demonstration to show how to render a white birch against a dark background. Here the sky is the dark backdrop. I'll use permanent blue, burnt sienna, raw sienna, and black India ink, a piece of rough Arches watercolor board, and No. 10 and No. 6 round watercolor brushes.

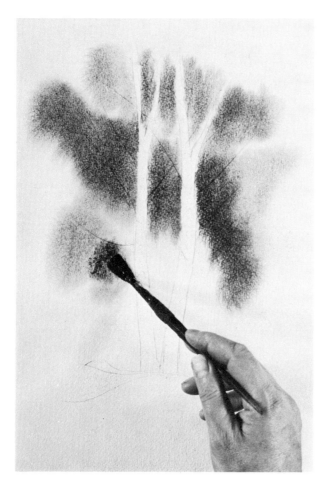

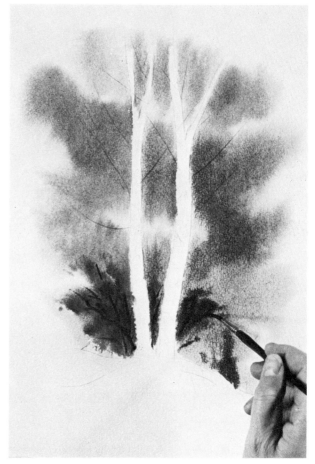

1. I wet the area with a No. 10 brush, making sure to leave the birches dry. Now, still using the No. 10 brush, I flood a mixture of permanent blue and burnt sienna, on the cool blue side, into this area to create cloud formations.

2. As these washes settle down into the paper, I paint in, with the same brush, mixtures of burnt sienna and permanent blue, on the warm brown side of the mixture, for the shape of a bush. I paint in a little of the same colors, but on the cooler side of the mixtures, for distant trees on the lower right. Then I use black India ink and the No. 6 brush to paint in the branches while the area is still damp.

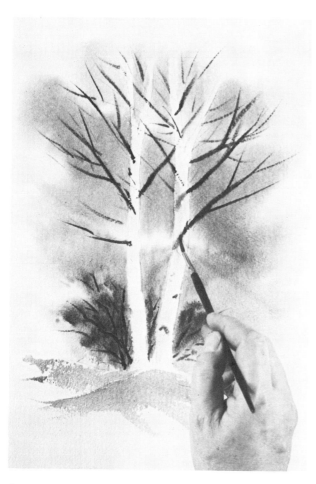

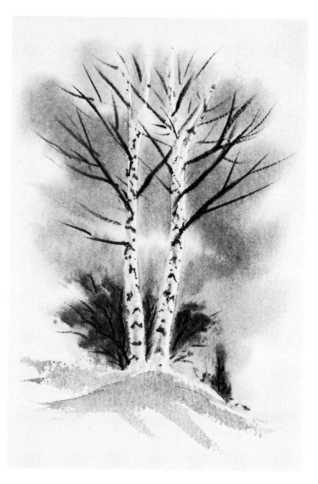

3. *Next I paint in some washes of cool blue, using permanent blue with a touch of burnt sienna, for snow shadows at the bottom of the bushes. The sky area is still damp, and I paint in pure India ink with the No. 6 brush for branches, giving a slight, soft effect. I wet the right-hand birch with clean water and work in a tint of raw sienna. Then I start rendering the birch texture, using black ink and burnt sienna.*

4. *I finish the textures on the right birch trunk and treat the left birch trunk in the same manner. Now the demonstration seems complete.*

DEMONSTRATION 7
BIRCH IN SUMMER

In this demonstration I mask out the white birches with masking tape to preserve the white paper while flooding washes and sponging paint over them.

My palette consists of permanent blue, cobalt blue, olive green, raw sienna, burnt sienna, and black India ink. I'll use a natural sponge, a No. 6 round brush, and a No. 3 small round brush on Arches rough watercolor board.

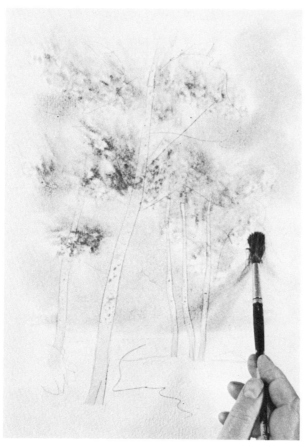

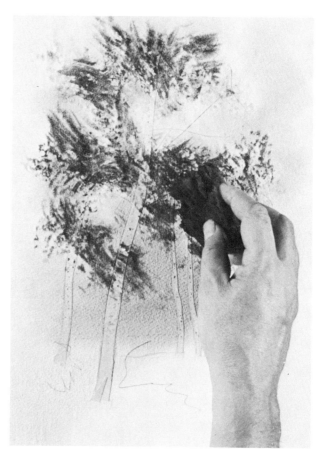

1. I gently press strips of masking tape over the drawing of the birch trees. I make sure I can easily see the pencil line through the single strip of tape. I use an X-Acto knife to cut out the shapes of the trees and then peel away the outer excess. The trees are now masked out. I wet the sky area with clear water and a sponge, followed by a wash of raw sienna and permanent blue, flooded in with a No. 6 brush. Then I paint in thicker mixtures of raw sienna and olive green, using the same brush.

2. As the area dries slightly, I use a natural sponge to squish in stronger mixtures of olive green, burnt sienna, and raw sienna for foliage treatment. To this mixture I add a bit of black India ink and slightly stipple over the foliage again.

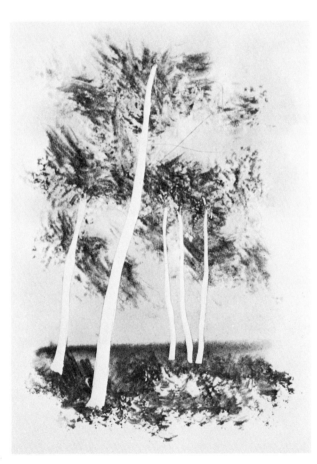

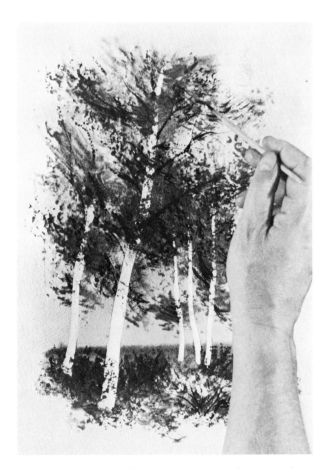

3. With a No. 6 round brush, I paint in permanent blue and burnt sienna on the blue side of the mixture in fairly thick measures for distant water. I sponge in mixtures of permanent blue, burnt sienna, and olive green for the foreground grass and shrubs. When this is almost dry, I strip away the masking tape ever so gently, leaving white paper for the trees.

4. With the foliage still damp, I sponge in the same mixture of colors and melt them into the existing foliage. With a No. 3 round brush, I put in mixtures of black ink and burnt sienna in the foreground to render a bush. Then I brush in a few strokes of the same mixture for branches.

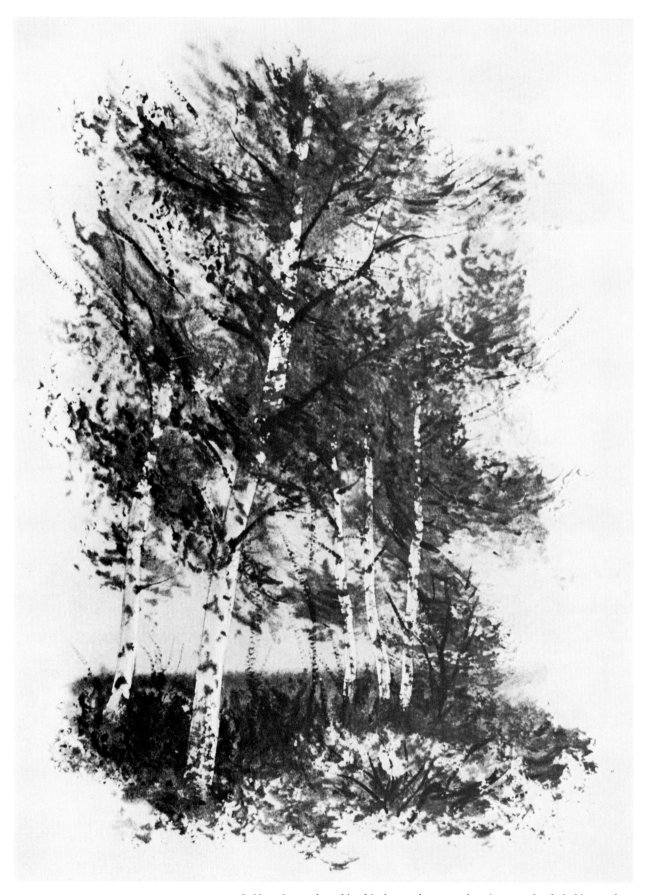

5. *Next I wet the white birches and use a pale mixture of cobalt blue and raw sienna with the No. 3 round brush to render form and shadow. While this is still wet, I spot in burnt sienna and black ink to complete the illusion of birch texture.*

Foregrounds are a vital part of most pictures because they tend to lead the eye into the important parts of the painting. This demonstration will be wet-in-wet with both sponge and brush. My palette is permanent blue, burnt sienna, raw sienna, olive green, and black India ink. A sheet of 300 lb Arches cold-pressed paper soaked in water and stretched on a drawing board is ready. My tools include a natural sponge, a No. 6 round brush, and a 1" flat round brush.

BUSHES AND WEEDS IN THE FOREGROUND

1. I wet the entire foreground area with clean water and a sponge. I flood olive green and raw sienna wet-in-wet using the 1" flat round brush.

2. I scoop up burnt sienna and permanent blue on a natural sponge, and I stipple and twist it into the wet pigment.

3. *I carry on with the same procedure and the same colors, adding olive green and raw sienna in thick, juicy applications. Then I mix black ink into these thick colors and stipple wet-in-wet on top of the existing color. I also stroke the sponge upward in short motions to simulate weed and grass.*

4. *Then I use the No. 6 brush to further render the weeds and bushes, using burnt sienna and black India ink.*

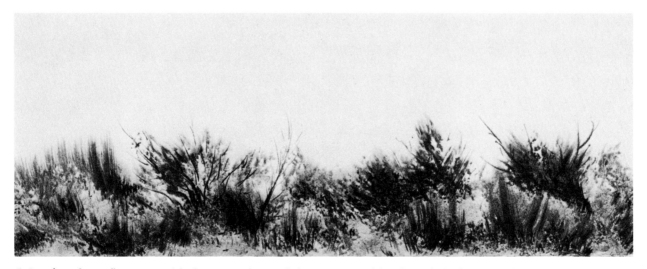

5. *I make a few refinements with the same colors and the No. 6 round brush, and the foreground is finished.*

The theme of this picture is sunlight filtering down through heavy green foliage, throwing patches of light across a rutted path. This is a good chance to use the sponge stamping technique in rendering summer foliage.

My palette consists of cobalt blue, raw sienna, permanent blue, sap green, olive green, burnt sienna, plus black India ink. My tools are a 1″ round flat brush, a No. 10 round brush, and a No. 6 round brush. I prepare a sheet of 300 lb Arches rough paper, soaked and stretched by taping and stapling to a ¾″ plywood board.

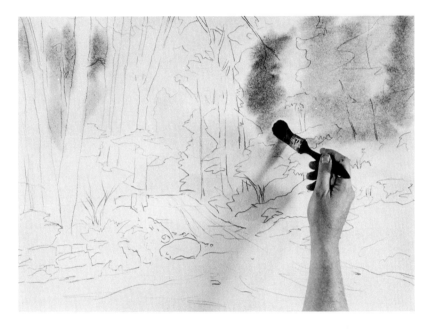

1. *I sponge the entire upper part of the paper with clear water. With the 1″ flat round brush, I paint in varying mixtures of warm and cool raw sienna and permanent blue.*

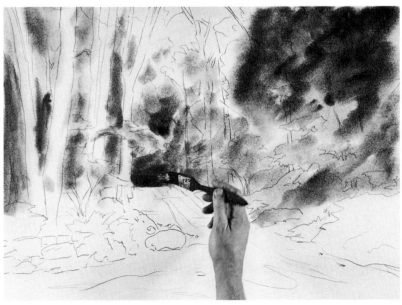

2. *With the same brush, I place swatches of raw sienna where lighter foliage will appear later. I continue mixing and painting in stronger values of raw sienna and permanent blue with a little olive green added. I put in a dark value above the path, using burnt sienna, permanent blue, and sap green.*

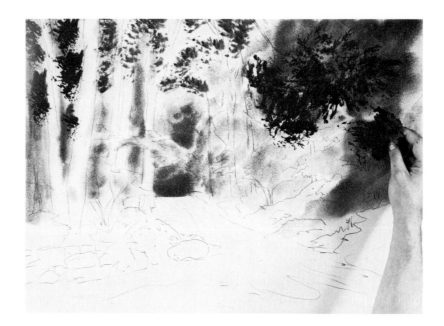

3. *Now, with a natural sponge, I pick up colors of sap green, permanent blue, raw sienna touched with a little burnt sienna and black India ink and start to squish these into the damp surface, twisting and stroking slightly to achieve some interesting, varied effects in the foliage.*

4. *I carry this on throughout most of the foliage area. I also deepen the value directly above the path that leads into the woods. I try not to get too much paint on the main trunks of the trees that will be painted later.*

5. *The area is now dry, and I paint in the tree trunks on the left, using burnt sienna, permanent blue, and olive green and varying their tonal qualities slightly. I paint the tree near the center with the light breaking behind it in a warmer tone than the rest to avoid monotony.*

6. *I add a small tree on the right and paint in the top of the path using burnt sienna with a No. 6 round brush. I gently rewet an area in the dark foliage on the right and form a tree trunk with the No. 10 round brush. I add a few more trees near the path to complete that area for now. I sponge the foreground wet with clear water, and with my 1" flat brush, I swash in washes of raw sienna and burnt sienna to start the foreground rendering.*

7. *I complete the foreground by using permanent blue, cobalt blue, and burnt sienna for cooler, grayed-down shadows. While the area is still moist, I drag the brush through for a drybrush effect. I pick out some small highlights for stones with the tip of the No. 6 round brush and throw in a small shadow of each stone for further texture. Now, before the area dries, I quickly cover the upper half with old newspapers to protect it and spatter burnt sienna mixed with black India ink into the moist paper for the final textural results.*

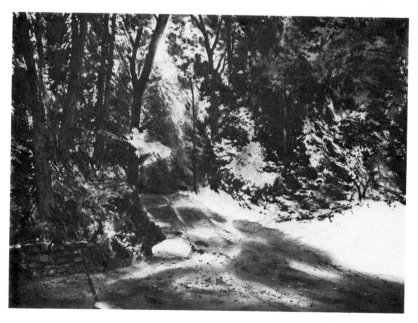

8. *After this area dries, I wet the wall area on the left and paint a wash over the wall in uneven patches of warm and cool permanent blue and raw sienna. I now draw and paint in the dark areas between the stones with the No. 6 round brush, using black India ink, burnt sienna, and permanent blue.*

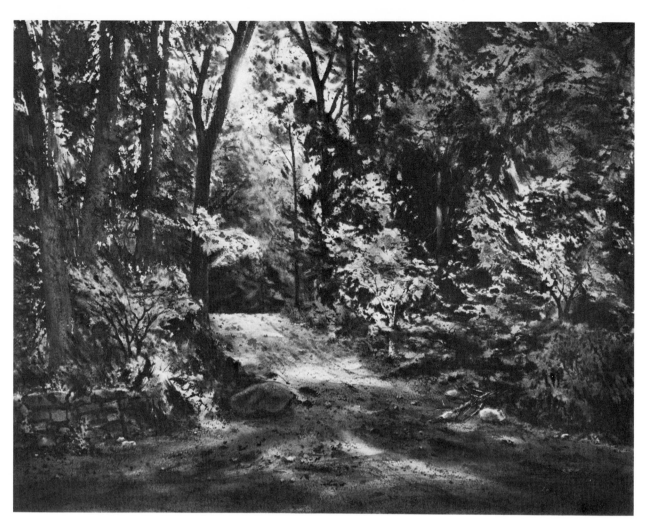

Woodland Path in Summer. *I paint in the large rock next. I decide to make it quiet by keeping it in the shadows, using permanent blue and raw sienna with the No. 6 round brush. I scrape out a small dead branch and some larger stones with an X-Acto knife to break up the long running line on the right side of the path. With the No. 6 round brush, I use cobalt blue and burnt sienna mixed lightly to paint in the stones, with permanent blue and burnt sienna plus black ink for the dead branch. I paint in the branches of the bush behind the stone wall next, using permanent blue and black ink. I scrape out a small white trunk up the path on the right with an X-Acto knife and delicately paint it in with cobalt blue and raw sienna.*

DEMONSTRATION 10
STREAM WITH ROCKS IN SUMMER

Here's an opportunity to render sky, stream, trees, and rocks in a simple manner with a combination of wet-in-wet and the direct approaches. I'll use permanent blue, olive green, burnt sienna, raw umber, and black India ink. With No. 3, No. 10, and No. 6 round brushes, natural sponges, and a sheet of cold-pressed Arches 300 lb stretched watercolor paper, I'm ready to start.

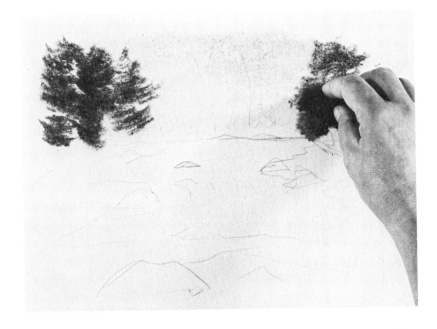

1. With a sponge, I wet the sky and tree area with clear water. I paint a pale mixture of permanent blue with a touch of raw umber into the wet area with a No. 10 round brush. Then with the sponge I squish olive green and raw umber into the damp area to start rendering the trees.

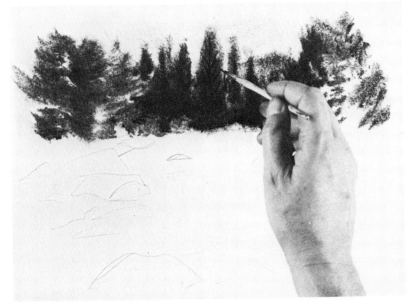

2. I paint in permanent blue, olive green, and burnt sienna with the No. 6 brush to simulate trees. I put black India ink in next with the No. 3 brush for a deeper value and texture and also for tree branches.

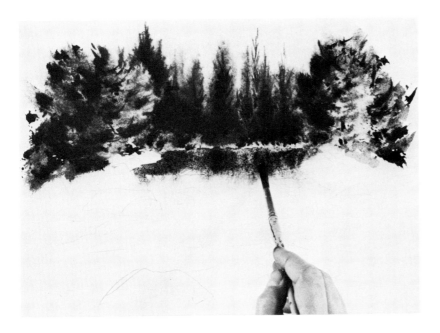

3. I wet the water area next and with the No. 6 round brush, paint in wet reflections of the dark trees, using permanent blue, olive green, burnt sienna, and India ink.

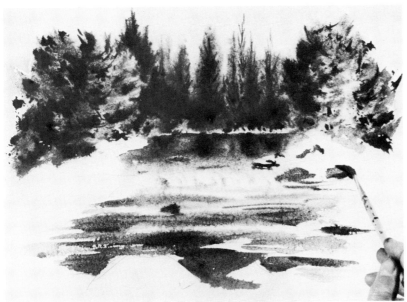

4. With the same brush, I paint in the small rapids very simply with permanent blue and burnt sienna mixed to a cool gray. I carry the water area down into dry paper with brisk movements of the brush. Then I put a suggestion of rocks into the water and on the right-hand shoreline, using the No. 6 brush with grays mixed from burnt sienna and permanent blue.

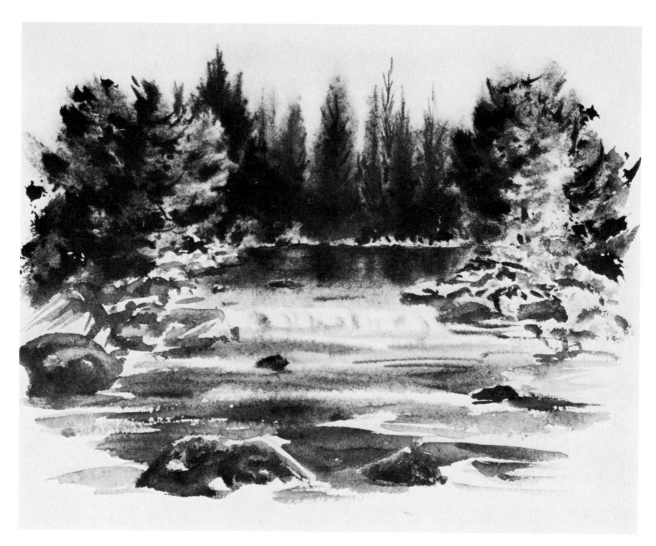

5. I finish off the rocks on both shorelines using the same brush and colors. Then, using the No. 6 round brush, I paint in the larger rocks in the foreground with burnt sienna and permanent blue mixed alternately warm and cool. Next I put a very light, pale wash of pure burnt sienna over the rocks on the shorelines to warm up the highlights that up to now have been white paper. Finally, I tone down the distant shoreline with a little raw umber and permanent blue.

In this demonstration I'll use washes of color to simulate water flowing over a falls for the simplest rendering of this subject. For contrast I use both the semidry and the wet-in-wet techniques. My palette has burnt sienna, raw sienna, permanent blue, olive green, and black India ink. My tools are No. 10 and No. 6 round brushes, a sponge, and a cardboard squeegee. I've stretched a 300 lb sheet of Arches rough watercolor paper and I'm ready to paint.

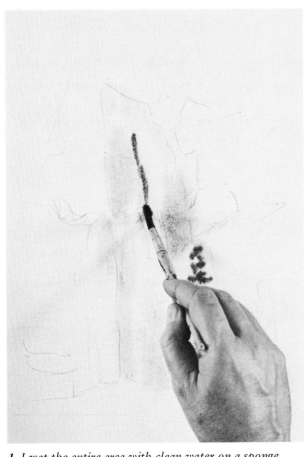

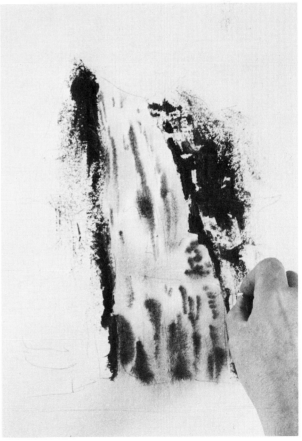

1. I wet the entire area with clean water on a sponge. With a No. 6 round brush, I gently place in pale washes of permanent blue in vertical strokes. Next I put in mixtures of burnt sienna and permanent blue to simulate shadows of rocks, some nearly jutting through, and others hidden under, the rush of the water. I leave this area until it's nearly dry.

2. Next I use a folded cardboard squeegee to scoop up globs of pure burnt sienna and permanent blue. I squeegee these colors into the practically dry paper to render the rocks. The contrast between the semidry approach for the rocks and the fluid or wet approach for the water helps give a better illusion of water.

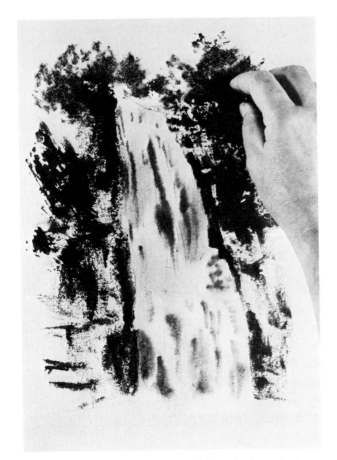 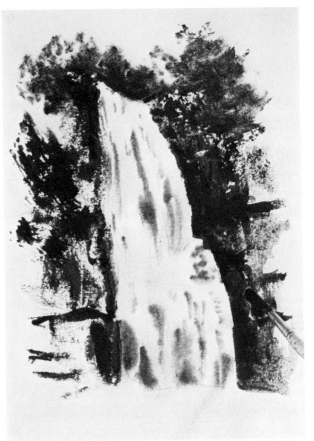

3. *Next I rewet the top portion of the painting quickly with clean water and sponge and stipple in the suggestion of small trees and bushes using olive green and raw sienna.*

4. *Then on the right side with the No. 10 round brush, I gently throw a wash of cool blue — permanent blue and burnt sienna — on the rocks to pull them together into a better mass grouping.*

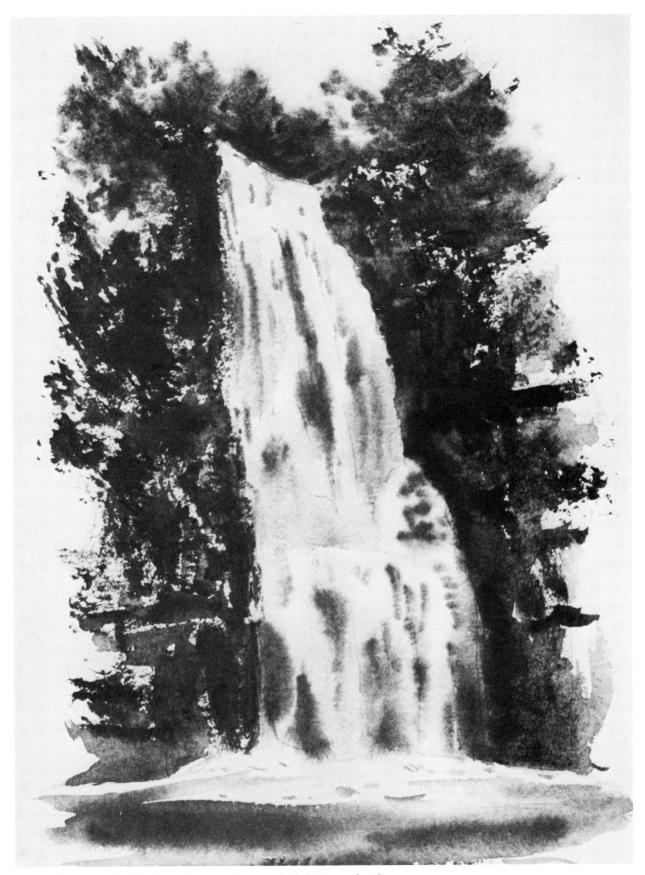

5. *I do the same thing for the rock formations on the left. To render the pool of water at the bottom of the falls, I swish a wash of permanent blue and burnt sienna in a direct approach on dry paper, and I touch the open white area here and there with the tip of the brush to simulate ripples of water.*

DEMONSTRATION 12
INLET
IN WINTER

This picture shows an iced-over inlet with the stream of water melting and pouring over a portion of the ice. The soft, furry feeling of the trees against the snow-laden sky is of particular interest to me. As you will see in the different steps, I work quite hard in altering them in different stages to obtain this effect.

My palette consists of permanent blue, cobalt blue, burnt sienna, raw sienna, olive green, cadmium red, and black India ink. I use the same sponges and brushes and a stretched sheet of 300 lb Arches paper.

1. I sponge the sky area with clean water, then using a 1¼″ flat brush, I lay in a wash of pale raw sienna.

2. With the same brush, I place in a graded wash of permanent blue, cobalt blue, and burnt sienna mixed to a fairly neutral gray. I grade the wash darker at the top to lighter at the bottom. Using a sponge, I stroke into this wet wash colors of permanent blue and burnt sienna to start the distant trees. This is a base wash on which I'll build the larger trees.

3. With the same colors and sponge treatment, I further develop the trees in the background and start to develop the large group of trees on the right side.

4. While the area is still wet, I use black India ink with a No. 6 round brush to work in some of the tree trunks and branches. I also use cobalt blue and burnt sienna to paint the base of the birch trunks in silhouette. Now I take an X-Acto knife and scratch out a few twigs for further rendering of the birches.

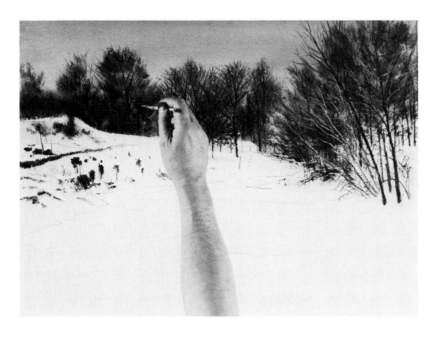

5. I wet the left bank with clear water and for the tiny scrub pines work in olive green, burnt sienna, and permanent blue with a small sponge. I develop the trees further in the upper rear portion with burnt sienna, permanent blue, and ink, using the No. 6 brush.

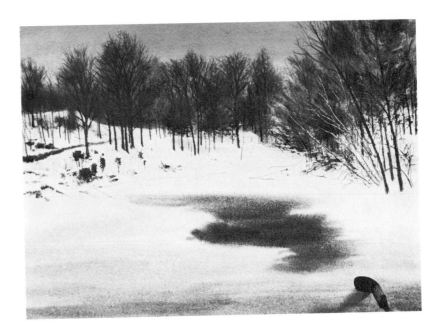

6. *Then, I wet the bottom half with a sponge and flow in washes of raw sienna and cobalt blue with a 1" flat round brush to start rendering the ice. I work in deeper washes of permanent blue and burnt sienna wet-in-wet to start the flow of water melting over the ice.*

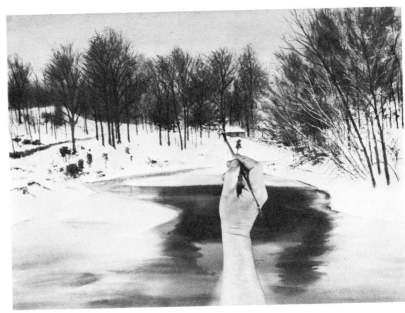

7. *I work still further to bring the ice to a wet, glassy surface. With the No. 6 round brush, I paint in a few reflections of trees to further the illusion of water and let the area dry. I then place in the little cabin, using cadmium red and a touch of cobalt blue, with a little ink for the window.*

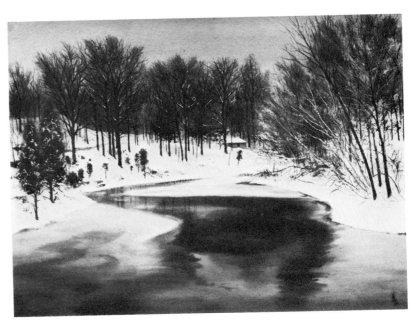

8. *Still the picture doesn't seem to work just right at this stage. Further development of the trees in the sky seems necessary. So I carefully rewet sections with a No. 10 round brush and reshape the branches further with a No. 6 round brush, using burnt sienna, permanent blue, and ink. I place in some small bushes on the left bank, using olive green, burnt sienna, and permanent blue with a sponge, to try to improve the balance of the picture. Next, I add some snow in the tree branches by scraping them with an X-Acto knife. The trees on the skyline still bother me, so after rewetting, I rework with the same colors, striving for a harmonious arrangement.*

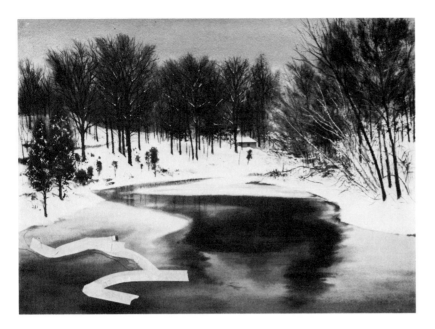

9. *I am still displeased with the total effect; the picture doesn't seem to balance right. So I mask out an area in the left foreground with masking tape.*

Wanaque Inlet. *(Below) Then I sponge out the area outlined by the tape until the paper is nearly white, and I also sponge out a small area on the right. I paint in the shrubs and bushes in both these areas with variations of the previous colors and ink, using a sponge and No. 6 round brush. I diffuse these colors slightly by blowing clear water with a fixative sprayer over them while they are still wet. Now the picture balances out and has a better unity of rhythm throughout. (See page 65 for color reproduction of this painting.)*

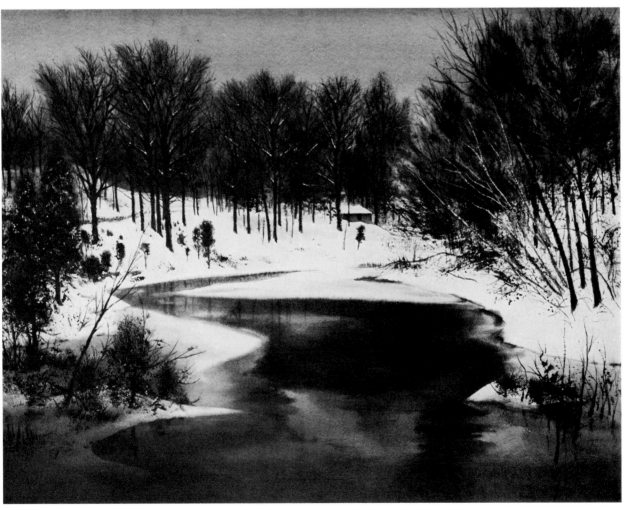

DEMONSTRATION 13
SEACOAST IN SUMMER

This picture of the coast of Maine depicts the heavier and deeper mood of nature as one moves north. The landscape catches the sun's rays at a slightly different angle, and the heavy rocks and dark pines seem to hold back the reflected light.

I'll use burnt sienna, raw sienna, raw umber, sap green, olive green, permanent blue, cobalt blue, cadmium red, and black India ink. I assemble my natural sponges, the same assortment of brushes, and a stretched sheet of 300 lb cold-pressed Arches paper.

1. I double-wet with clear water the upper section of the paper where the water and sky will be painted. With my 1″ round flat brush, I flood in a pale wash of raw sienna and burnt sienna mixed together. Next I paint in wet the misty water with light reflecting from it, using cobalt blue and burnt sienna.

2. I wash in cobalt blue and burnt sienna with the same brush for the cloud formations. Then I paint in the islands with a No. 10 round brush, using cadmium red and permanent blue for a purple hue and a touch of burnt sienna to suggest the land color at the base. The paper is almost dry now, and I have to work with a drier mixture of paint to keep the water from creeping out of the brush into the almost-dry washes.

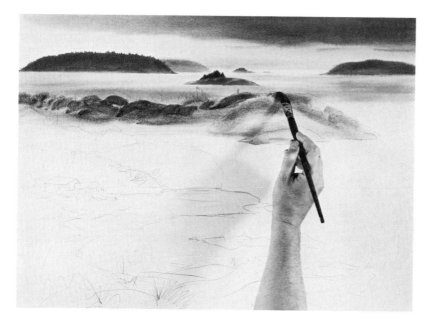

3. I complete the islands quickly to beat the drying time, and I deepen the water just above the large peninsula with cobalt blue and burnt sienna. Now I let that area dry completely. I wet the land area with a large flat brush and clear water. I paint in burnt sienna and raw sienna with a ¾" flat sable brush for an underlay of rock and earth formation. I paint in olive green, sap green, and raw sienna as a base for the pine formations.

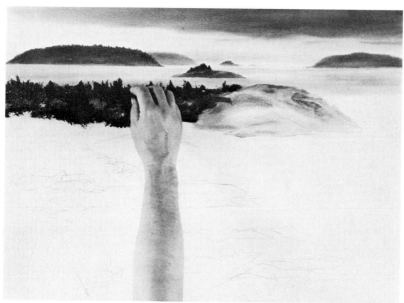

4. I use a sponge to insert raw umber, sap green, and India ink for the pines.

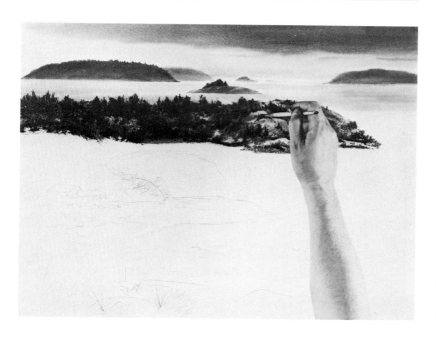

5. With the No. 6 brush, I texture, stipple, and drybrush little pines as well as land and rock formations, using sap green, burnt sienna, and permanent blue.

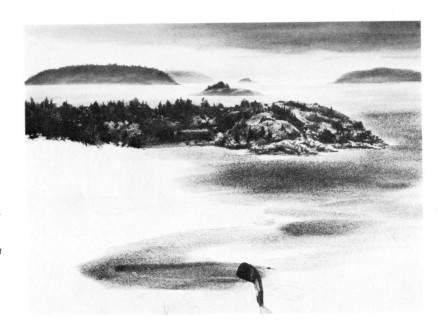

6. *Now I wet the bottom half with clear water using a brush and sponge. I deliberately leave little dry spots of paper around the base of the peninsula to simulate breaking water. Then I flood in a mixture of cobalt blue, permanent blue, and cadmium red with my 1" round flat brush.*

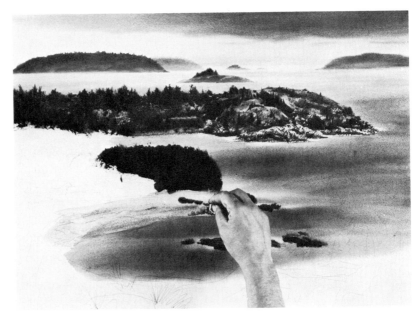

7. *I sponge in a dark mass of pine trees using permanent blue, sap green, and ink. I paint in a base of color with raw umber and raw sienna for the rocks, using a ¾" flat sable brush. Next, with a piece of folded cardboard loaded with burnt sienna and permanent blue, I squeegee in the rock shapes on the land and in the water.*

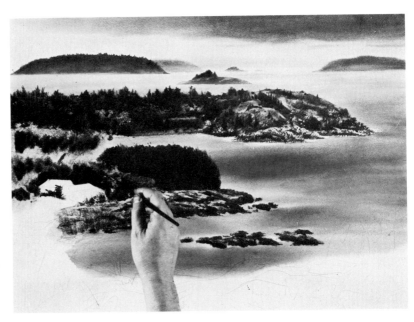

8. *While this area is still wet, I continue to paint in more trees, using raw sienna, sap green, and olive green with a ¾" flat brush.*

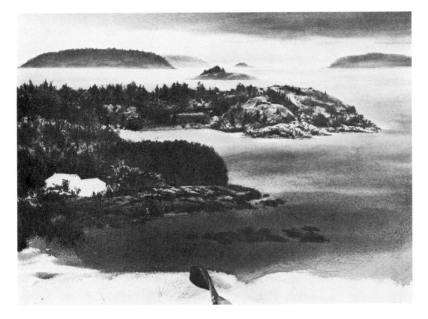

9. I continue to paint in land and tree formations, cutting around the buildings. Now I let the whole area dry. I mix up a deep mixture of permanent blue and burnt sienna, and without rewetting the area, I briskly paint this deep wash over the existing water and rocks with a large flat brush. I want to keep this low key so your eye will tend to look beyond the foreground into the depth of the picture.

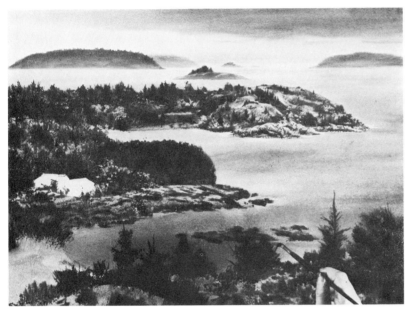

10. While the surface is still damp, I drag the wash down to the bottom of the foreground. I insert burnt sienna to warm up the foreground and quickly paint the pine trees into the damp water, using sap green, burnt sienna, and India ink with a No. 6 brush.

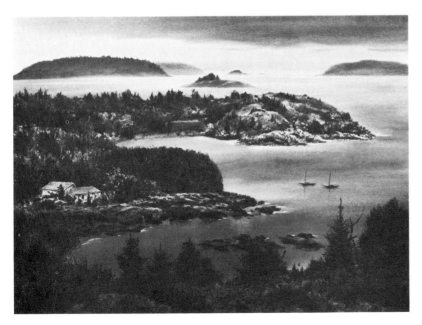

Coast of Maine. I further deepen the foreground with burnt sienna and raw umber and the trees with the greens and ink. I texture this area with a sponge, using permanent blue, sap green, and ink. Then I deepen the upper left water area with cobalt blue and burnt sienna. With a No. 6 brush, I place in the buildings, using burnt sienna plus a touch of cadmium red for the tile roofs, cobalt blue and raw sienna for the white walls, and black ink to suggest windows. On the top, I mask out two slender strips in the water and paint in more color to give the water better balance. (See page 65 for color reproduction of this painting.)

COLOR
DEMONSTRATIONS

Wanaque Inlet. See pages 56-59 for a black and white demonstration of this painting.

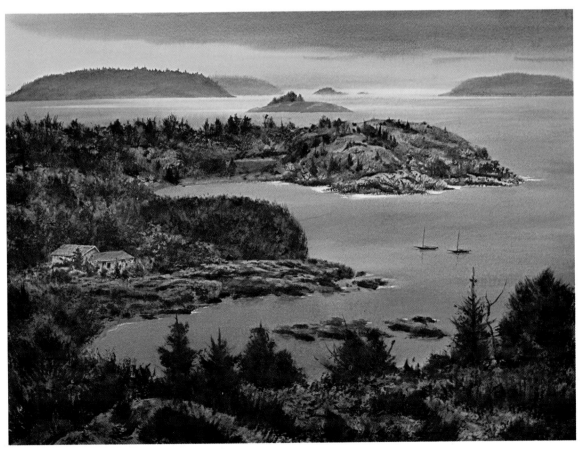

Coast of Maine. See pages 60-63 for a black and white demonstration of this painting.

COLOR DEMONSTRATION 1
WOODS IN LATE SPRING

This scene depicts late spring trees and growth along a river bank. I depend very heavily on the sponge technique, working wet-in-wet, to achieve a light, airy, textural effect in the foliage, set off by dark mysterious passages in the water. The flash of sunlight across the bow of the small boat creates a contrasting note.

My palette consists of burnt sienna, raw sienna, raw umber, sap green, olive green, cobalt blue, permanent blue, Winsor red, and black India ink. I stretch a sheet of 300 lb Arches cold-pressed paper on a drawing board and set up a selection of various-size natural sponges and my usual array of brushes.

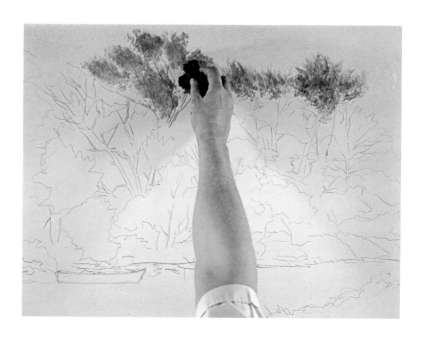

1. I double-wet the paper with clear water and a sponge, from the top of the paper down to the shore of the river. Then I brush in a light tint of raw sienna with a 1¼″ flat brush over the entire sky area. I introduce a pale mixture of cobalt blue and permanent blue into this wet area at the top of the sky and slowly grade it down into the raw sienna. Next I squish a sponge of olive green with raw sienna and raw umber into the wet sky to start the rendering of the trees.

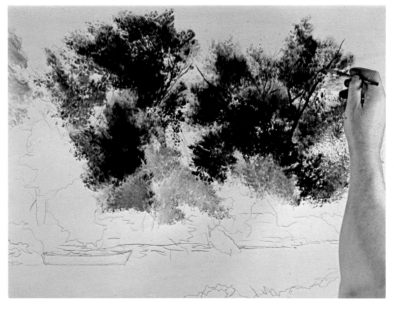

2. I develop the trees further with more pure color of raw umber, raw sienna, and olive green sponged in and then deepened further by sponging in darker areas with burnt sienna and permanent blue. As the wash begins to dry, I use burnt sienna with black India ink and a No. 6 round brush to develop the tree trunks and branches.

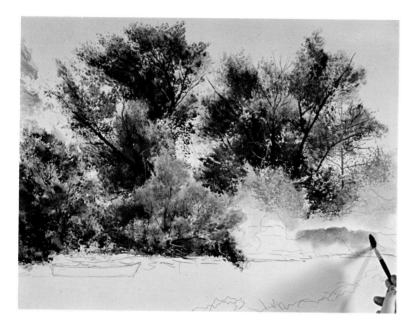

3. With a No. 10 round brush, I use sap green and raw sienna for a brighter green on the central bushes and small tree groups below the large trees. With a sponge, I gently touch the same areas with a mixture of burnt sienna and permanent blue for textural effect. I use a deeper mixture with more permanent blue on the smaller trees to the left, over the boat, to point up the brighter central trees. The paper is now dry. With a No. 10 brush, I place a wash of cobalt blue and Winsor red where I'm going to add some bushes and let it dry. I put in more branches in the trees. Then I wet the river bank area with clear water and paint it in on the right using sap green and raw sienna.

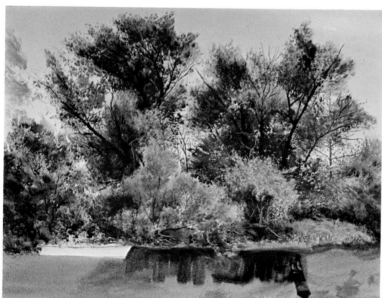

4. I develop the river bank further with touches of burnt sienna and permanent blue. I work the darker areas of green in back of and around this bank and around the violet-colored bush with a No. 10 round brush and sponge, using the same mixtures as before. I form the lighter branches by pressing out the damp areas with the handle end of the brush. Then with a sponge and clear water, I wet the entire water area, except the boat. I wash in a mixture of olive green and a touch of sap green grayed a bit with burnt sienna as a base color for the reflecting trees. Using a 1" round flat brush, I introduce some darker tones into this, using permanent blue and burnt sienna to start the dark tree reflections.

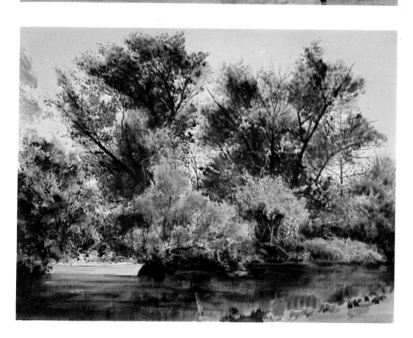

5. Using a No. 10 round brush, I paint in some areas of the foreground bushes, with sap green, burnt sienna, and permanent blue, while the washes are still wet to keep them diffused and out of focus. I also paint a pale tint of warm color over the boat. I develop the water further with deep mixtures of burnt sienna and permanent blue until the paper is almost dry, finishing it up with touches of drybrush. This slight textural effect in conjunction with the texture of the trees aids the overall appearance of textural unity.

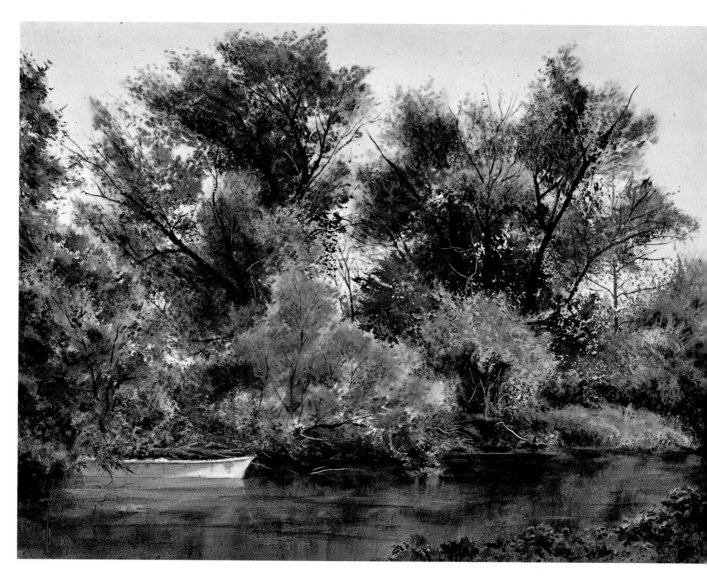

The Whisper of Spring. *I complete the boat using cobalt blue and burnt sienna for a cast shadow, keeping the shadow cooler near the light edge. Then I finish the foreground growth with a No. 6 brush and raw sienna, sap green, burnt sienna, permanent blue, and India ink. I next paint in some more branches to finish the bushes and trees. I'm still not satisfied so I drag a branch over the boat and into the water to tuck the boat into the shoreline better and break the vertical top edge of the boat.*

In this demonstration, I want to capture bright fall sunlight streaming through golden foliage, with various mixtures of dark and bright colors reflected in the stream. Again, I work primarily with the wet-in-wet technique, to fuse color and light together.

I'll use Winsor red, raw sienna, raw umber, olive green, burnt sienna, permanent blue, cobalt blue, cadmium orange, and black India ink. I soak a sheet of Arches 300 lb cold-pressed paper, stretch it on a drawing board, and gather around me natural sponges and my usual selection of round and flat brushes.

COLOR
DEMONSTRATION 2

BRIGHT FALL, WOODS AND STREAM

1. Using a sponge, I wet the paper down to the bottom of the trees with clean water. I then paint in the sky with a ¾" flat sable brush, using cobalt blue and a touch of olive green for the blue sky and cobalt blue and burnt sienna for the gray clouds. Next I wash pure raw sienna into the central trees using the same brush.

2. I flood the raw sienna to the other trees to create color continuity. I sponge burnt sienna and raw umber in place and put in some Winsor red with a small piece of sponge. I sponge in permanent blue and burnt sienna for the dark shadow accents and raw sienna and raw umber for the smaller tree in the foreground.

3. While the surface is still wet, I paint in some tree trunks with burnt sienna and ink using a small No. 6 round brush. I place in permanent blue, olive green, and burnt sienna for base colors in the surrounding trees. I paint in and refine shapes by painting around the small right foreground tree with a ¾" flat sable brush.

4. I work in additional stippling with the sponge using raw umber, olive green, and black India ink to develop the pine trees. I sneak in some burnt sienna and permanent blue here and there. I use a No. 6 or No 8 round brush with raw umber and ink to paint in the trunks of trees and branches and let the area dry.

5. With a sponge, I wet and double-wet the bottom half with clear water. I first introduce cobalt blue with a ¾" flat sable brush and then wash in mixtures of burnt sienna, raw sienna, and raw umber. With the same brush, I paint in the distant strip of land under the trees with olive green and raw sienna and, with the No. 6 round brush, place in the branches against the sky with raw umber and a little India ink. I wash in raw umber and burnt sienna on the middle land strip and texture with a sponge using olive green and raw umber. Then I paint in the branches of the little tree with the No. 6 round brush. I sponge in the foreground with burnt sienna, olive green, and raw umber.

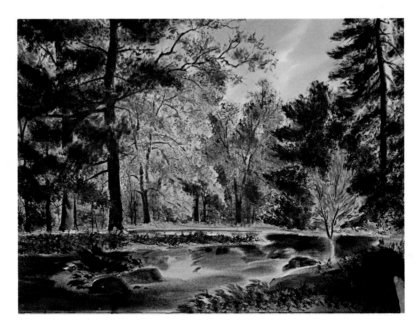

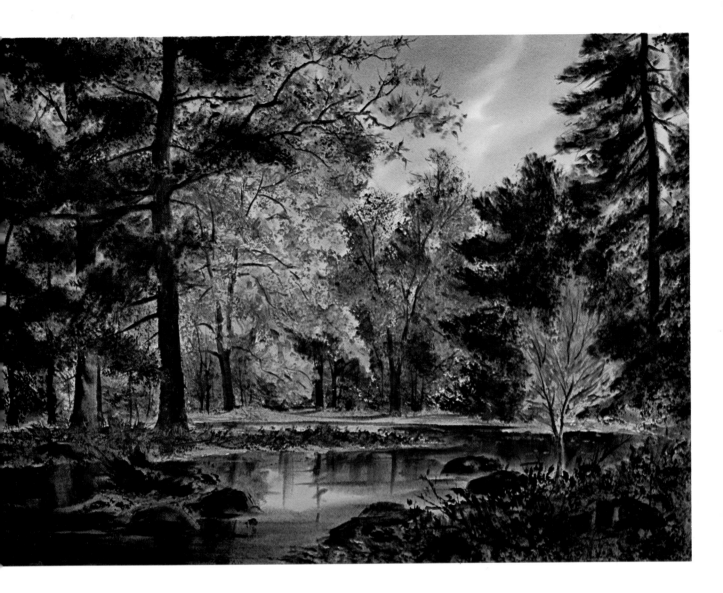

Autumn Song. I develop the foreground texture further using burnt sienna, olive green, and permanent blue with a sponge. Then I define the rocks and growth on the left side, using olive green, permanent blue, and burnt sienna with India ink. Next I paint in branches of a bare bush in the foreground with a No. 6 brush, using mixtures of burnt sienna, permanent blue, and India ink. Then I flick into the bush some thick splotches of pure cadmium orange for color harmony among the dried leaves. I add some more reflections with the colors I used for the trees, and ink, and, finally, I shape up the rocks with burnt sienna, permanent blue, and ink.

COLOR
DEMONSTRATION 3
MIDSUMMER'S MEADOW AND POND

Water Street dead-ends at this lovely strip of grass and water in the backyards of Clinton in New Jersey's Hunterdon County. To portray a still, heavy summer day, I'll use burnt sienna, cobalt blue, permanent blue, raw sienna, olive green, sap green, raw umber, and black India ink. Natural sponges and the usual round and flat brushes are my main tools here. I stretch a 300 lb sheet of cold-pressed Arches paper on a drawing board and have lots of clear water on hand.

1. Using a 1¼″ large flat brush, I place a wash of raw sienna into the pre-wet surface of the sky portion of the picture. Now, using the same brush, I paint in a mixture of cobalt blue and burnt sienna mixed on the cool blue side. Using broad horizontal strokes and starting with a deep tone at the top of the sky, I grade the color slightly lighter down to the horizon. With a small No. 6 round brush, I insert a mixture of cobalt blue, burnt sienna, and olive green into the wet sky to form the distant trees. Then I pick up the same colors on a damp sponge and press them lightly into the area for texture. I repeat this stippling, adding India ink, for the final texture.

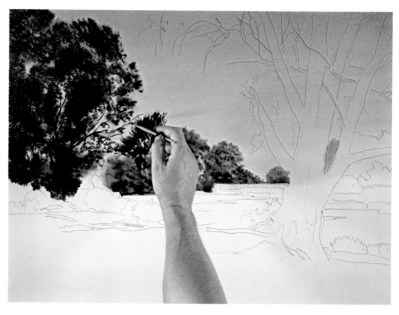

2. I use the same procedure for the left-middleground trees. Then I add some tree branches using burnt sienna and India ink with the No. 6 brush.

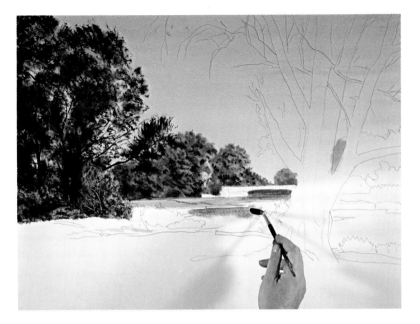

3. *Using a No. 10 round brush, I wet the area of the water with clear water and, with a No. 6 round brush, put a wash of raw sienna and olive green into this to show a stretch of lily pads. Next I introduce a deeper mixture of permanent blue and cobalt blue with a touch of burnt sienna to gray this mixture and paint wet-in-wet to start defining the clear water passages.*

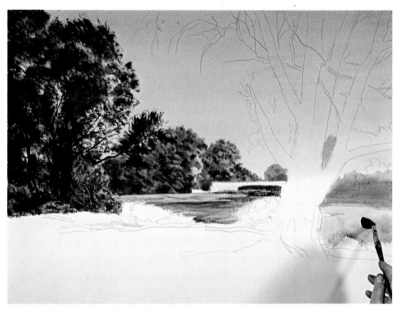

4. *I carry out the same procedure on the other side of the large tree. I wet this area with clear water, and with a No. 6 brush I develop the distant bushes and trees using raw sienna and olive green. I paint the water in with the same brush using cobalt blue and burnt sienna.*

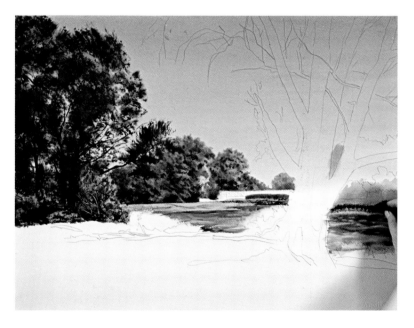

5. *I further develop the distant tree areas with the sponge treatment using cobalt blue, raw sienna, burnt sienna, and black India ink. Then with a No. 10 round brush, I paint the water in with deeper tones, using horizontal strokes.*

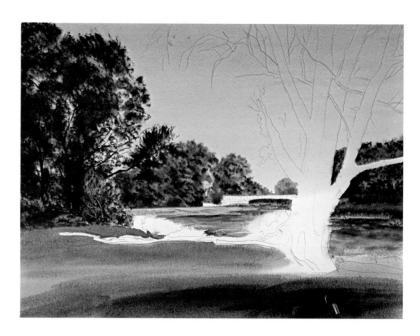

6. I carefully rewet the right bottom sky area between the tree branches and, using a No. 10 round brush, paint in the distant trees with olive green and raw sienna. Then while this area is still moist, I stipple in burnt sienna, permanent blue, olive green, and black ink with a sponge. I double-wet the foreground with clear water and boldly flood in washes of olive green, sap green, and burnt sienna, using a 1" flat round brush.

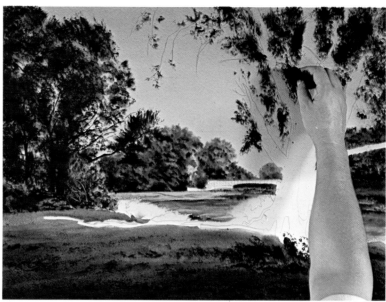

7. While this area is still moist, I dry-brush the foreground, using the same brush, and spatter it with dark mixtures of permanent blue and burnt sienna. Next I paint in some hanging branches and the suggestion of leaves at the middle top of the picture with a No. 6 round brush. I rewet the sky area over the large tree with clear water in a fixative sprayer and sponge in raw umber, raw sienna, and olive green for foliage. I then reinforce this by sponging in darker mixtures of the same colors, adding a little sap green and black India ink.

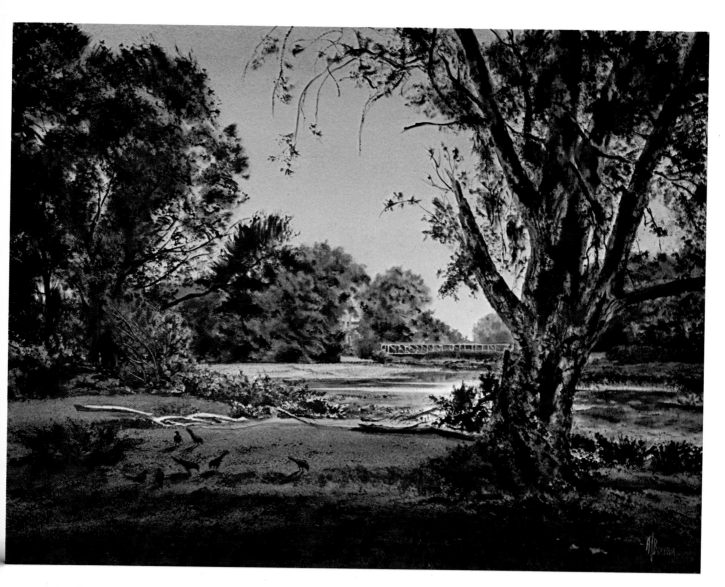

View from Water Street. *While the area is still moist, I paint in some of the tree trunk and branches with a No. 10 round brush and then let this area dry. I complete the trunk and branches by first rewetting with water and then stippling burnt sienna, raw umber, and black India ink, with light touches of sap and olive greens, lightly on the trunk with a sponge. I add the dark bush by sponge and No. 6 round brush to produce close value relationships that add mystery to the painting. Then I put in the birds to reverse the conflict of this heavy mood with decorative flicks of life. I pick up the streak of light in the water by masking and sponging out color. Last, using burnt sienna, I put in the suggestion of the building in the far distance for a slight change of color, pace, and interest.*

COLOR DEMONSTRATION 4
AUTUMN POND

Brilliant sunlight streaming through the autumn foliage, mingling with vivid reflections in a mirrored pond, set the stage for this watercolor. My palette is cadmium red, cadmium orange, sap and olive green, burnt sienna, raw sienna, raw umber, cobalt blue, permanent blue, and black India ink. I stretch a 300 lb cold-pressed Arches watercolor paper on a ¾'' plywood board. I have large and small natural sponges and the usual watercolor brushes at hand.

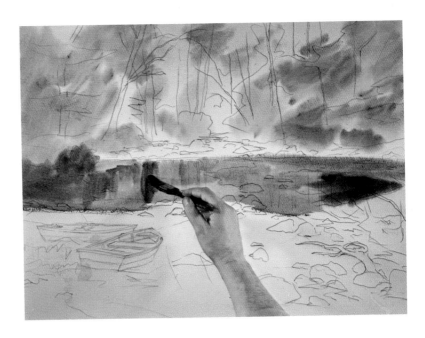

1. I wet practically the entire sheet, from the top of the paper to the bottom of the water's edge, with a sponge and clear water. With the round flat 1'' brush, I boldly swish washes of burnt sienna, raw sienna, and a little sap green into the damp paper above the pond. I brush in cobalt blue near the shoreline. I introduce raw sienna and cadmium red with cobalt blue into the pond area. I paint in dark reflections with the same brush using permanent blue, burnt sienna, and black India ink.

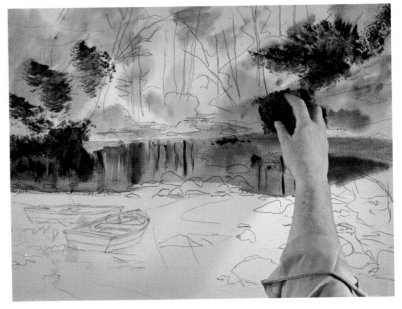

2. I paint in more reflections of trees, using ink and burnt sienna with a No. 6 brush. While the foliage area is still damp, I use a large sponge with burnt sienna, raw umber, and cadmium orange to stipple and squish in place varied textures.

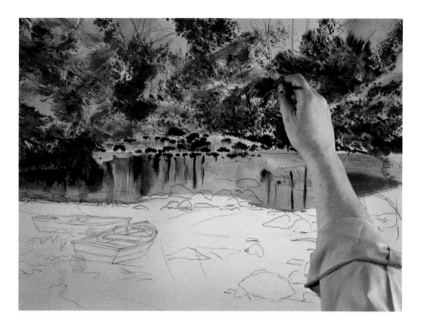

3. Again I use the sponge technique and the same colors to sponge in further development of the foliage. Then I add some permanent blue and India ink to these colors and stipple in a finished textural effect. I further develop the water in the rear and, with a ¾″ flat brush, paint in rocks using permanent blue and burnt sienna. I also render the reflections with the ¼″ flat brush to complete the clear water. I mix burnt sienna and India ink with a No. 6 brush and paint the trees and branches in the foliage.

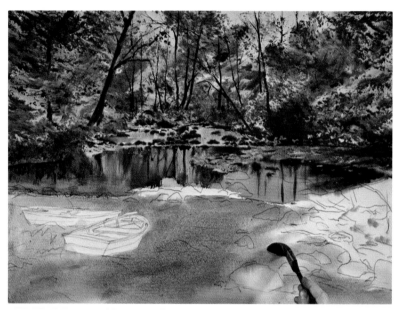

4. I now use a stippled and drybrush treatment with cadmium red, cobalt blue, and burnt sienna to create the large patch of leaves on top of the water. I let this entire area dry. With clean water, I then wet the lower half of the paper, except for the boats, and with brisk strokes of the 1″ flat round brush, I flood in washes of burnt sienna, cobalt blue, and cadmium red.

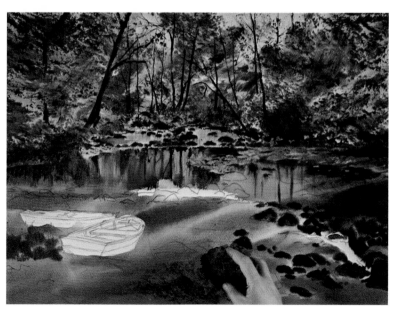

5. I add more of the same colors in the foreground; then with the flat round brush, I quickly suggest rocks by mixing dark colors of burnt sienna and permanent blue. I paint in olive and sap green on the left side of the boats. I scoop up burnt sienna and permanent blue on a damp sponge and briskly texture in the foreground.

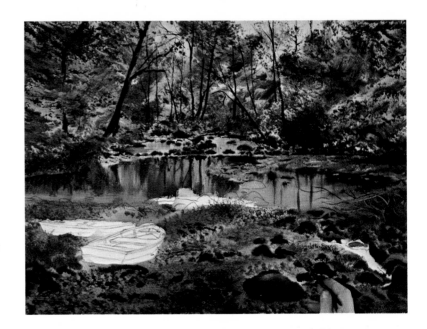

6. I alternate sponge and brush, using the same colors, to further develop the foreground. I also spatter permanent blue and burnt sienna with a brush to complete the foreground, and then I let it dry.

7. Next I paint in the rocks in the center with a No. 10 brush, using cobalt blue, permanent blue, and burnt sienna. I take a razor blade and scrape a few highlights through the center foreground. I then erase this area briskly with a soft plastic eraser to bring up the lighter areas. I now paint in the boats using ¾" and ¼" flat sable brushes to slip in the violet color (I mixed cobalt blue and cadmium red for the violet). I use burnt sienna for the stains on the boats and raw sienna to warm up the violet washes. I use a little India ink with the small brush for accent.

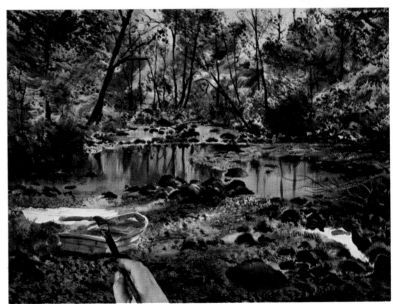

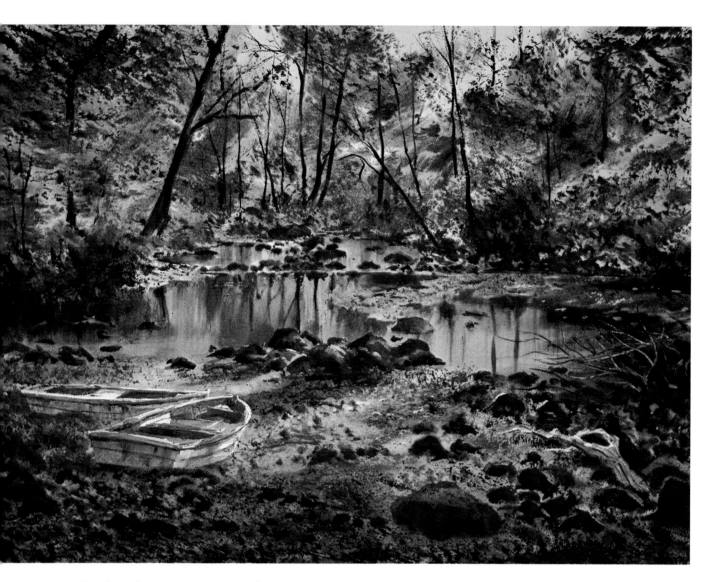

Autumn Pond. *I refine the boats and paint in the old stump, using the same color scheme as for the boats. A few flicks of pure cadmium orange in the foreground complete the picture.*

COLOR DEMONSTRATION 5
WOODS IN WINTER, NO SNOW

This painting is a winter scene in the bare woods just before the snow flies. Again, I bring my sponges and brushes into play by sponging, painting, spattering, and drybrushing to render this rocky landscape. The mood calls for a low color key with somber tones. My palette consists of burnt sienna, raw umber, cobalt blue, permanent blue, cadmium orange, cadmium red, and black India ink. I stretch a sheet of Arches 300 lb cold-pressed paper and I'm ready to go.

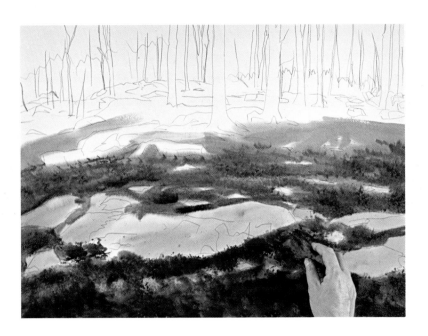

1. With clear water, I sponge the entire paper up to the bottom of the woods. I work this area wet-in-wet as far as I can until it dries. I mix cadmium red, cobalt blue, and permanent blue to a purple hue and brush this into the area of the foreground rocks. I paint a stronger and deeper mixture of burnt sienna and raw umber around these rocks with the round flat brush. Next I deepen this with the same colors plus permanent blue. I pick up deep mixtures of permanent blue and burnt sienna on a sponge and squish in deep textures of grass around the base of the foreground rocks.

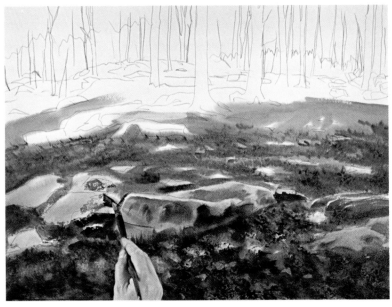

2. I use the ¾″ flat brush with cobalt blue, permanent blue, and burnt sienna to render the rocks in the foreground wet-in-wet.

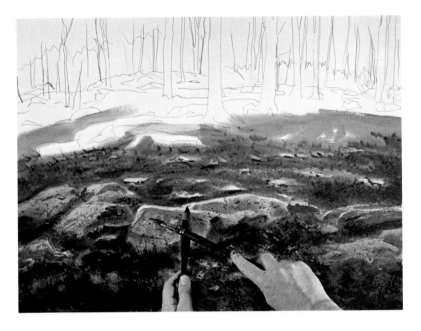

3. I spatter the rocks and foreground for varied effects of texture by mixing dark colors of permanent blue and burnt sienna on a semidry brush and smacking it against another brush handle to flick the color off into the moist washes.

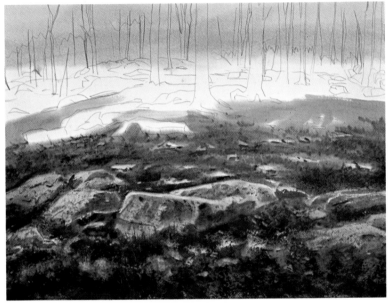

4. I now leave this portion of the picture to dry. I wet the sky area in back of and below the trees with clear water and a sponge and flood in a wash of warm burnt sienna for late afternoon color.

5. I wash in cobalt blue and permanent blue with the flat round brush, grading the color beginning at the top from dark to light. Then I work into the wet sky a deep, dark mixture of permanent blue and burnt sienna on the cool side to lay in the distant rocks, shrubs, and trees. Then I put a mixture of cadmium red and cobalt blue into the rocks in the middleground. Next I paint mixtures of burnt sienna and raw umber around these with a ¾″ flat sable brush, allowing the color to drift into the dry washes below and melt into them.

6. *I stipple for simulated tree branches into wet sky, using raw umber, burnt sienna, and cobalt blue. I mix and paint in burnt sienna and India ink with the No. 6 round brush for trees and branches. Then I use the sponge treatment for further texture in the middleground.*

7. *I spatter the middleground lightly, and then I quickly flick in pure cadmium orange with a small brush to give added life to the foreground. Using a small No. 6 brush with permanent blue, burnt sienna, and ink, I complete the trees.*

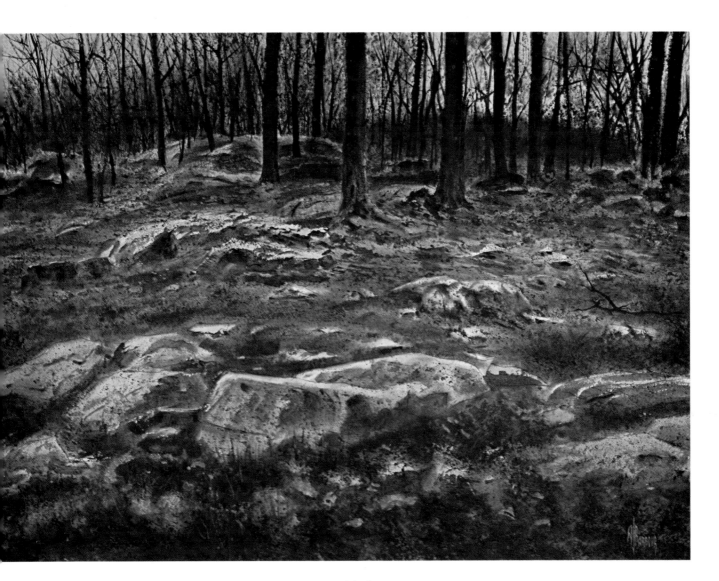

Advent of Winter. For a final touch, I stipple a little more with the sponge. After some careful thought, I put an extra rock in the middleground to balance and carry your eye through the composition better. To do this, I cut a hole in the shape of a rock out of a stiff piece of paper. I place the paper mask over the chosen area and sponge the rock-shaped area out with clean water before painting in the rock. Finally, I add a small dead branch on the right side of the middleground to change the pace and point back into the composition.

COLOR
DEMONSTRATION 6
MOUNTAIN IN WINTER

This winter scene is composed of three sections of Garrett Mountain and its surrounding areas in New Jersey. I thought of the picture from the beginning as having a late in the day, winter mood. I'll use burnt sienna, raw sienna, raw umber, cobalt blue, permanent blue, cadmium red, and black India ink. I assemble my usual sponges, brushes, and a stretched sheet of 300 lb cold-pressed Arches paper.

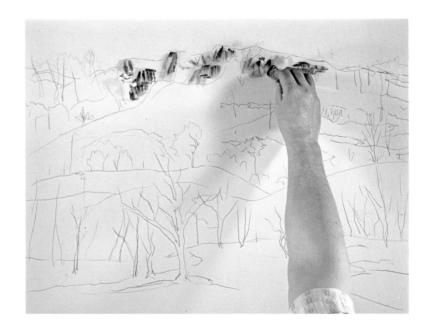

1. I wet the center mountain section with a sponge and clear water, and I wash in raw sienna in intermittent sections as an undercolor for the warm pervading light on the rocks. Then I use a folded piece of matchbook cover loaded with burnt sienna and permanent blue as a squeegee to apply color in this moist wash. I use short, downward strokes with the flat side of the cardboard and imprint with the edge to render the mountain rocks. This technique helps keep the rocks from looking stilted and contrived. (They're sort of a happening.)

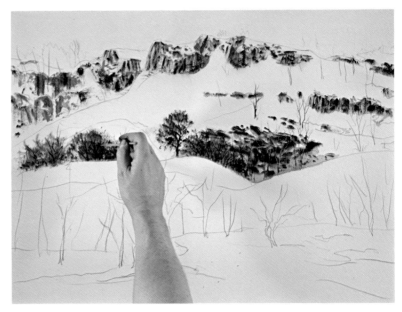

2. I rewet the lower section and paint in a wash of burnt sienna and permanent blue with a No. 10 round brush. Again I use the cardboard technique for the rocks, with the same colors. I give a little sponge treatment to the trees, using burnt sienna and raw umber. With a No. 6 round brush, I now put in a few bare trees and branches using burnt sienna and black India ink.

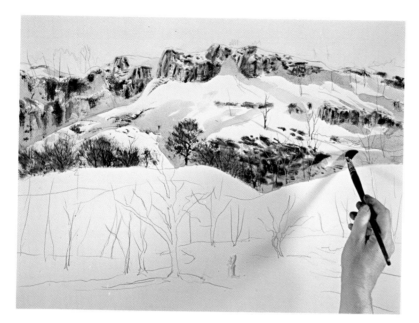

3. When this area is dry, I paint in a wash of cobalt blue and burnt sienna mixed to a cool gray. With a No. 10 round brush, I work the washes around various shapes. I also lay some washes over the mountain side on the left, and on shadows from the rock on the right at the top.

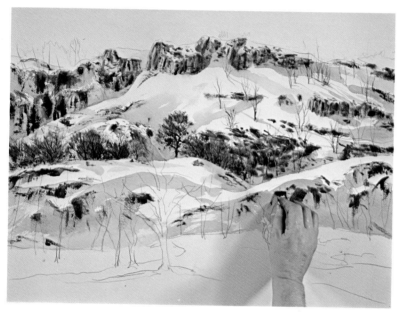

4. I paint in additional direct washes on dry paper. Partly by planning and partly by mishap, I invent various shapes using cobalt blue and burnt sienna for a cool gray, warmed here and there with burnt sienna and raw sienna. Once again I use the cardboard squeegee to render rocks, with burnt sienna and permanent blue, to keep the technique flowing along.

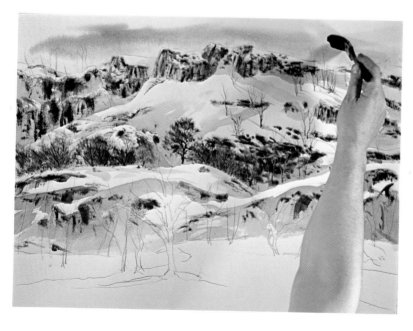

5. I wet the sky area with clear water using a brush and sponge, cutting around the top of the rocks, and I wash in a warm mixture of cadmium red and a little raw sienna with the 1" flat round brush.

6. *Now I paint in with the same brush a mixture of permanent blue and cobalt blue grayed with burnt sienna to form heavy clouds, dark in value, to set off the lighter mountain. While the sky is still wet, I paint in trees on the mountain, letting them melt into the sky for unity. For this I use permanent blue, burnt sienna, and India ink with the No. 6 brush. I work in more trees on the mountain, using a sponge with raw sienna for the small branches. Next I wet the foreground with clean water and a sponge. Using my round flat brush with cobalt blue, permanent blue, and burnt sienna, I brush in a blue-gray mixture, varying the wash in a warm and cool arrangement.*

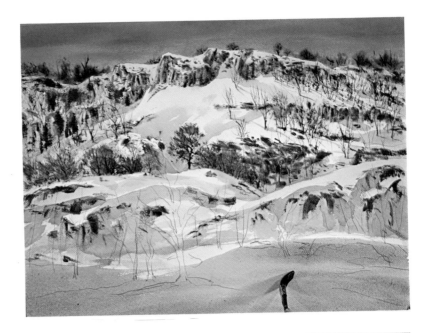

7. *When this is dry, I begin to work on tree groups in the foreground using No. 10 and No. 6 round brushes with burnt sienna and India ink. I stroke in some rock formations with a cardboard squeegee, again using burnt sienna and permanent blue. I build these trees with a maze of branches, working for a deep unity of value.*

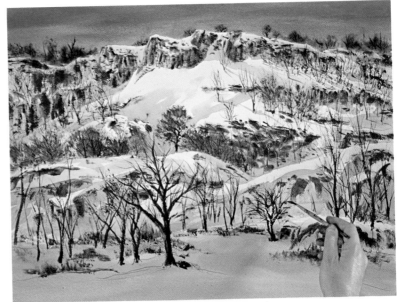

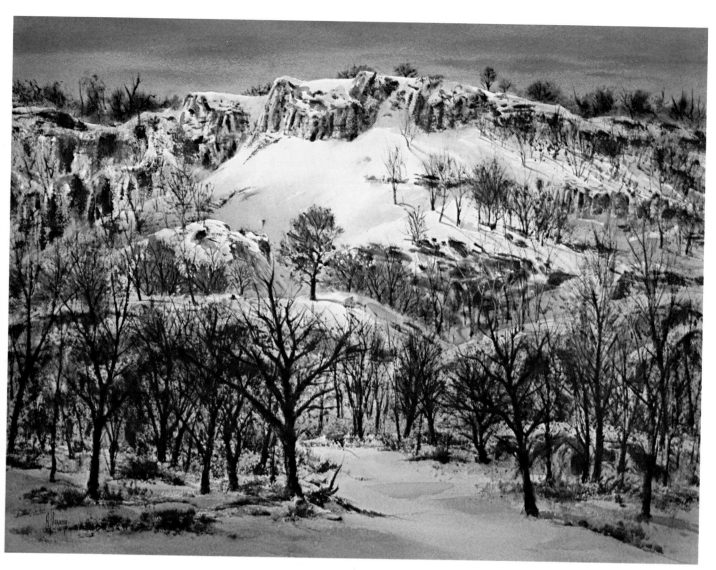

Garrett Mountain. *Finally I lay another wash of permanent blue and burnt sienna to deepen the entire foreground so you'll look over this to focus on the light on the mountain. When this is dry, I take a damp sponge with pure colors of burnt sienna and permanent blue and stipple over the tree branches to integrate them better into a mass group and also to subdue them a little more in relation to the mountain. As quickly as I stipple, I blow clear water with a fixative sprayer lightly over this area to slightly melt the paint into the trees. I throw another wash here and there over the sides of the mountain slopes to subdue and quiet them — to permit my eye to see, first, the light mountain, second, the path in the foreground, and, last of all, the other picture elements. Now the picture seems to work and I call a halt.*

COLOR
DEMONSTRATION 7
EARLY FALL
SHOWER

In this demonstration I'm going to capture the dramatic passing of a storm in early fall: the heavy clouds, the puddles in the road, the wetness of the grass, the clean fresh air — all familiar to our everyday life. My palette consists of cadmium orange, raw sienna, raw umber, burnt sienna, cobalt blue, permanent blue, olive green, cadmium red, Winsor red, and black India ink. I stretch a 300 lb sheet of Arches cold-pressed paper on a ¾" piece of plywood and arrange the same assortment of sponges and brushes.

1. With a sponge, I double-wet the paper with clear water down to the horizon and then flood light washes of raw sienna in the lower half with a 1" round flat brush. This gives a warm, luminous glow in contrast with the cool darker clouds. Next I paint in some deeper washes of burnt sienna and cobalt blue with the same brush for the darker cloud effects. After rinsing out the brush, I add light touches of cobalt blue between the lighter clouds, which heightens the illusion of vast, spacious skies.

2. I take a clean, damp sponge and scoop up pure colors of cadmium orange and raw sienna. I dabble these colors on the palette to integrate the colors ever so slightly on the sponge. I then press it quickly and lightly into the wet sky for the brighter-colored tree areas. Sometimes a slight, short stroke when pressing the sponge will transfer the color better from the sponge into the wet surface. I then pick up some permanent blue on the same sponge so that it intermingles slightly with the existing color and paint in some of the darker trees.

3. Now that this stage is dry, I look over the painting and the sky doesn't please me. So I pour a jar of clean water over the area I've just painted, and with a No. 10 round brush, I place large, juicy drops of Winsor red into the sky area on the upper left half and let this melt into the washes. Now as this settles, I load a flat 1¼" brush with a mixture of permanent blue and burnt sienna and paint in deep strokes for darker clouds. The washes break nicely; I'm lucky. I then strengthen the trees with a sponge and cadmium orange, cadmium red, and raw sienna. Since the clouds are still not dry, I quickly finish them with a semidry ¾" flat brush.

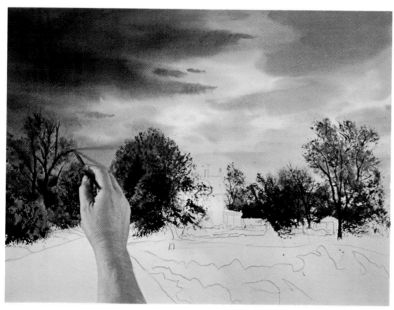

4. With a sponge, I quickly add some more bushes on the left using cadmium red, raw umber, and olive green. I use some burnt sienna mixed with black India ink and a No. 6 round brush to put in the semibare tree branches.

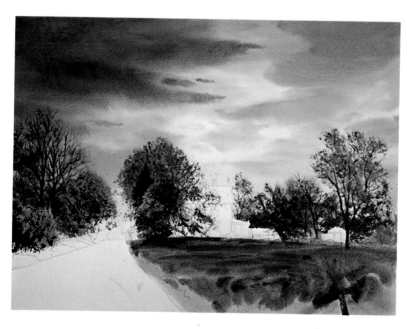

5. I add a little more background growth on the rear right side. I sponge the middleground and foreground with clear water and introduce, with a No. 10 round brush, mixtures of raw sienna and olive green for the grass area. Then I mix permanent blue into this, using the same brush. In the immediate foreground I intermittently mix raw sienna, burnt sienna, permanent blue, and olive green with a No. 10 round brush to render scrub bushes and brush. I keep these soft and diffused so the eye looks over them and into the picture.

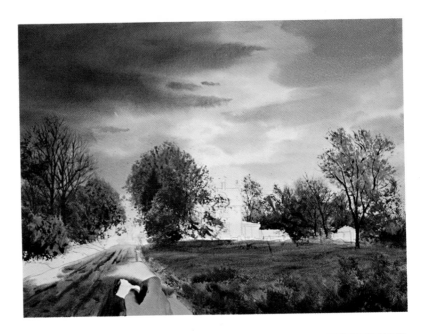

6. *I stipple in deep mixtures of permanent blue and burnt sienna with the sponge treatment to complete the bush and brush rendering. I now introduce a wash of raw sienna as a base for the road. I grade it deeper toward the foreground by graying it with permanent blue and burnt sienna. I cut the wash around the puddle areas, leaving white paper. Next I use a piece of cardboard with pure colors of permanent blue and burnt sienna scooped up on it to render the ruts in the road.*

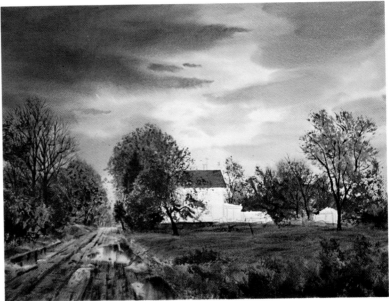

7. *I put reflections in the puddles with the ¾″ flat sable brush, using similar mixtures of colors to mirror the objects above. I then texture the road slightly with drybrush to complete this portion of the picture. I use a deep gray of burnt sienna and cobalt blue for the roof.*

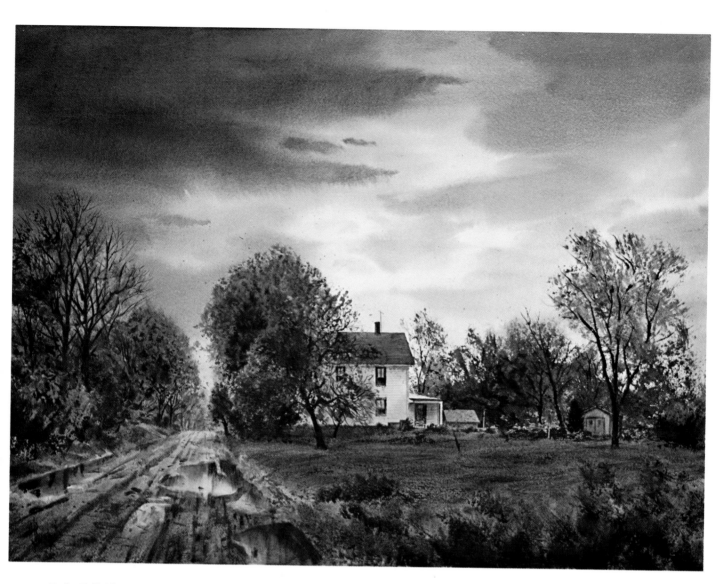

Early Fall Shower. *Here I paint in the side of the house with a gray, mixed from burnt sienna and cobalt blue on a No. 10 brush. As the gray on the side of the house dries slightly, I paint the windows wet-in-wet to keep them soft so they won't jump out at you. I use warm raw sienna in the center for shades and black ink to render windowframes. I use a purple of cadmium red and cobalt blue to paint in the rest of the small sheds, using India ink and a No. 6 round brush to render form in these objects. Now the picture is completed.*

COLOR DEMONSTRATION 8

WOODEN FENCE IN EARLY WINTER

This demonstration is of an old wooden rail fence in early winter. It's just before sunset on that rare kind of day when night marches in with warm, golden light. I use a sheet of 300 lb cold-pressed Arches paper, which I wet and stretch on a drawing board. My palette has Winsor red, cobalt blue, burnt sienna, permanent blue, cadmium orange, raw sienna, olive green, and black India ink, and I have my usual sponges and brushes on hand. Here I use the technique of mixing vertical planes of warm and cool color over the entire paper, as a base for the superimposed composition. This gives it unity, with interest of varying color mixes.

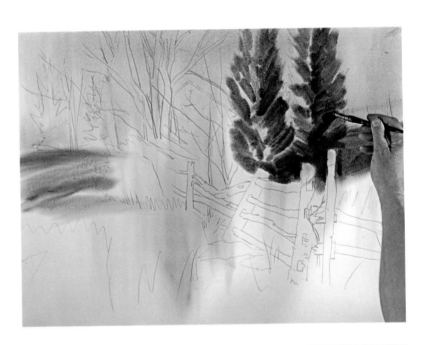

1. I brush a light, pale wash of raw sienna and cobalt blue in vertical strokes with a 1″ flat brush into the pre-wet paper. Then I brush pale washes of burnt sienna into this. I use a No. 10 round brush to introduce stronger wet washes of burnt sienna and cobalt blue into the background area. Then I work mixtures of olive green, permanent blue, and burnt sienna wet-in-wet to start rendering the trees.

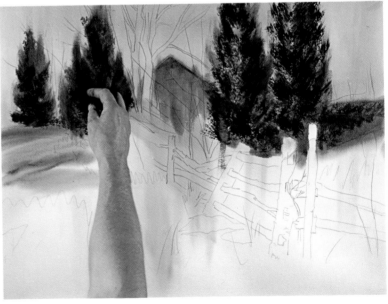

2. Using the ¾″ flat brush, I paint the barn in with a touch of Winsor red into burnt sienna, slightly toned down with cobalt blue, while the complete area is still wet. I deepen the low hill on the right with burnt sienna and permanent blue to create the mood of oncoming evening. I use a sponge loaded with raw umber, olive green, and permanent blue to stipple in the deeper structures and texture of the pine trees.

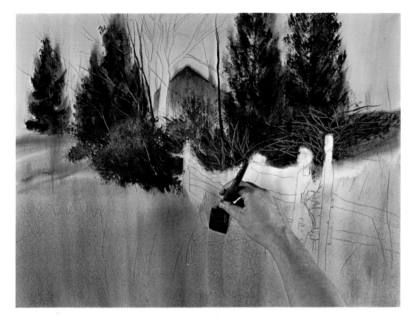

3. I quickly scrub and stipple, with the same brush, sponge, and colors, smaller bushes to the left of and behind the fence. To develop the feeling of the lighter branches around the fence posts, I use the back of a No. 10 or No. 6 round brush to squeeze out paint from the damp paper by pressing hard and stroking. Then I add some tree trunks with a No. 6 round brush using burnt sienna and black India ink. With vertical movements I stroke mixtures of permanent blue and burnt sienna briskly into the foreground with the 1¼" flat brush while the paper is still damp.

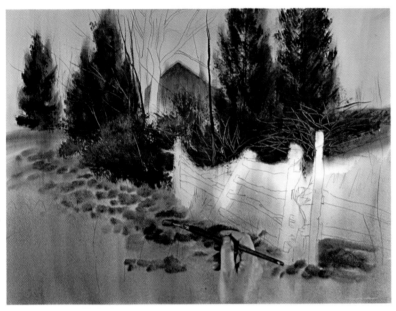

4. Before this area dries, I paint in mixtures of burnt sienna and permanent blue, using a ¾" flat sable brush in uneven mixtures of color, to indicate the clumps of grass.

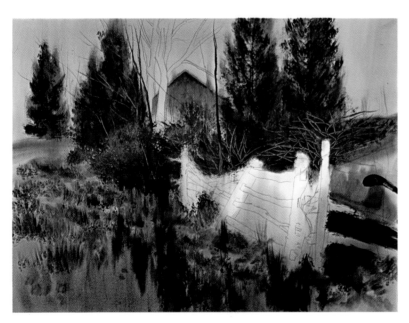

5. I use a light mixture of burnt sienna first. Then I use burnt sienna and permanent blue for a darker value, painting vertically between fence rails to strengthen the value in uneven vibrations of warm and cool color mixes. I use the vertical technique to paint in mixtures of the same colors to suggest clumps of grass in the middle- and foreground and ink mixed with these colors on a sponge to complete this area.

6. *By this time the paper is dry. I use black ink and burnt sienna to paint in trunks and branches, again alternating between a No. 6 brush and a No. 10 brush fanned out flat so it acts as a knife edge. I paint in a maze of branches to add a change of pace in texture and effect.*

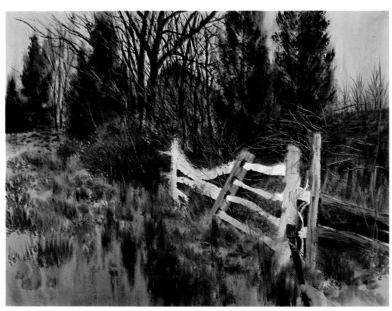

7. *For the development of the fence, I use a ¾″ brush with burnt sienna and permanent blue. I paint around a small group of vines with mixtures of dark paint — permanent blue and burnt sienna — and when this is dry, I tint the vine with burnt sienna for added variety. With burnt sienna and permanent blue, I paint in the fence rails on the right. Then I put in the trees on the small hill at the right with burnt sienna and India ink on a No. 6 round brush.*

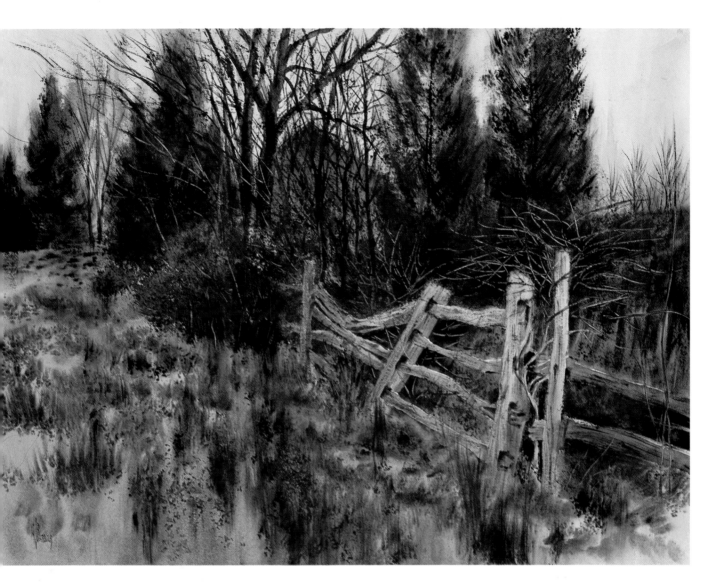

Come Winter. *For added interest I stipple the trees and parts of the fore-ground with a light touch, using permanent blue and burnt sienna on a sponge for further textural change against the smooth washes. I use a little touch of a drybrush with black ink on the fence posts to suggest wea-thered wood grain. I use a small sponge with pure, thick cadmium orange for highlights on the dried grass and bushes. I also crisp up sections of the barn roof for slightly better contrast, and the late fall mood is created.*

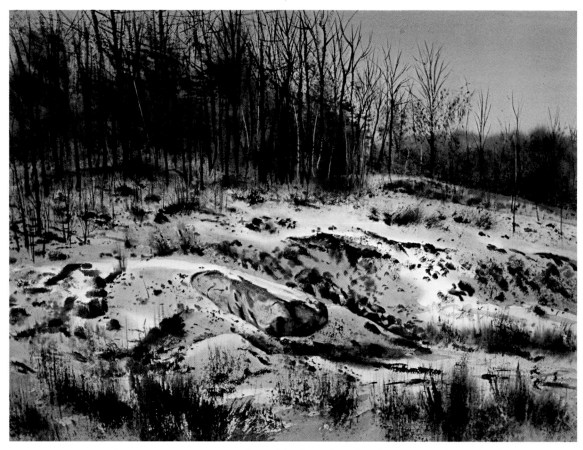

Edge of the Woods. See pages 127-130 for a black and white demonstration of this painting.

Colfax Avenue. See pages 138-141 for a black and white demonstration of this painting.

WEATHER
EFFECTS

DEMONSTRATION 14
SPRING RAINSTORM

The purpose of this demonstration of a springtime storm blowing in is to show how to work deep washes around crisp sunlit trees. My palette is cobalt blue, burnt sienna, cadmium red, olive green, raw sienna, permanent blue, and black India ink. I stretch an imperial size of Arches rough watercolor paper on a ¾″ plywood board, using one-quarter of the sheet for this demonstration. I use a ¾″ flat brush and No. 6 and No. 3 round brushes.

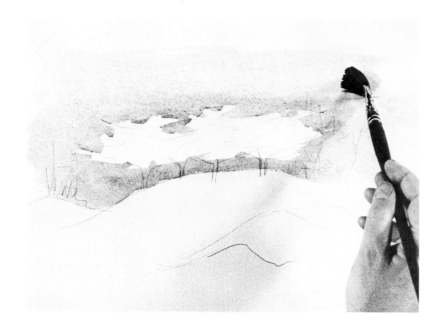

1. I work on the sky area, using a direct approach on dry paper. I cut around the trees with a ¾″ flat brush, using cobalt blue with a touch of burnt sienna and keeping the mixture on the cool blue side. I continue painting the rest of the sky with the same brush and the same colors.

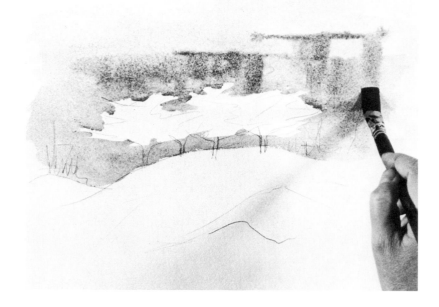

2. Next I place in wet a few horizontal strokes of cobalt blue and burnt sienna, again on the cool side. Then I paint wet vertical strokes into this with the same brush to simulate rain falling from the clouds.

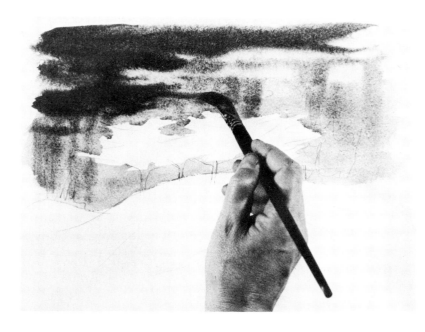

3. I whisk in the deeper clouds with sweeping horizontal strokes, using cobalt blue, permanent blue, and burnt sienna with the same brush.

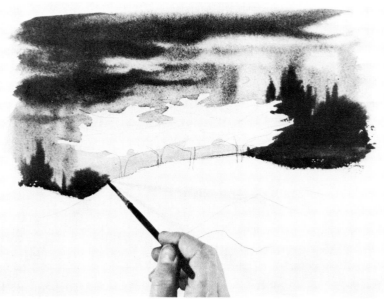

4. On the right side, while the sky area is still wet, I stroke in with a No. 3 round brush burnt sienna, permanent blue, and olive green for distant trees. For accent I also stroke in a touch of black ink. I carry out the same procedure on the left side and let the entire area dry.

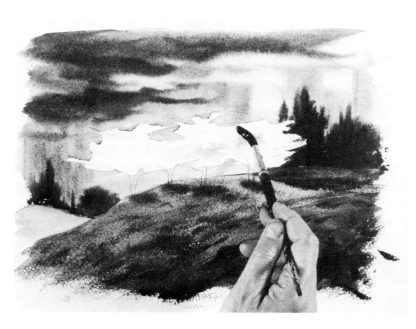

5. Next I use olive green and raw sienna to paint in the hill and burnt sienna and permanent blue on the warm burnt sienna side for the foreground area. I paint these colors directly on the dry paper with the ¾″ flat brush and let it dry. I then drybrush the area with thick mixtures of permanent blue and burnt sienna, using a No. 6 round brush. I also add a few strokes of India ink and burnt sienna in the foreground to simulate bushes and weeds. Again using the No. 6 round brush, I paint tints of cadmium red with the direct approach on dry paper to render pink blossoms.

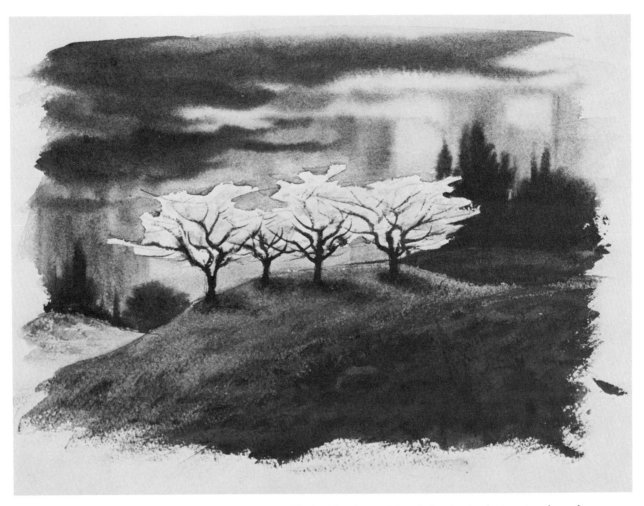

6. *Now, with the No. 6 round brush, I paint in the tree trunks and branches using black ink and burnt sienna and add texture to the left hillside with olive green and raw sienna. The effect is complete.*

This demonstration shows the rendering of heavy clouds and lightning at night. In this instance I use masking tape as a frisket. My palette is sap green, burnt sienna, raw sienna, permanent blue, and black India ink. My tools will be masking tape and No. 10 and No. 6 round brushes. A 300 lb sheet of Arches rough paper is stretched for the demonstration.

SUMMER THUNDER-STORM

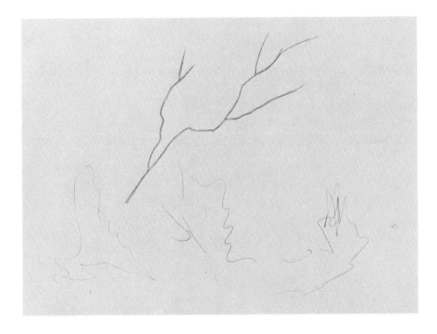

1. With an X-Acto knife I slice long slivers of masking tape, about 1/16" wide or less, from a standard roll of tape. I bend them into the desired design and press them on the paper with strong rubbing motions.

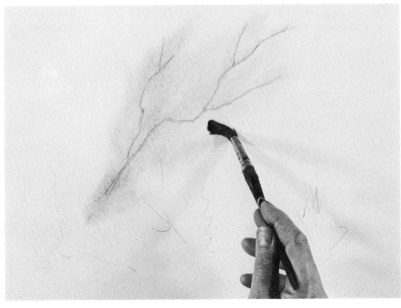

2. I wet the entire area with a sponge full of clean water. I flood a pale, light wash of raw sienna over the tape into the lightning area with a No. 10 brush.

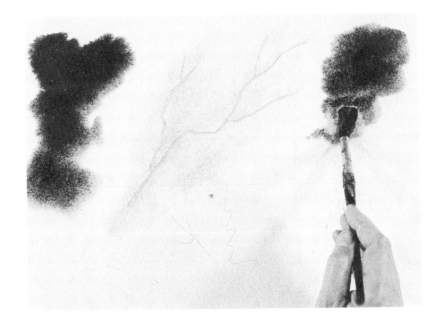

3. *With the same brush I paint extremely dark washes of permanent blue and burnt sienna on the cool blue side into the two opposite corners to form clouds.*

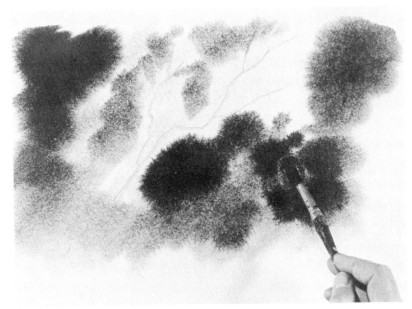

4. *I keep the clouds slightly lighter as I move toward the center where the strong light will be.*

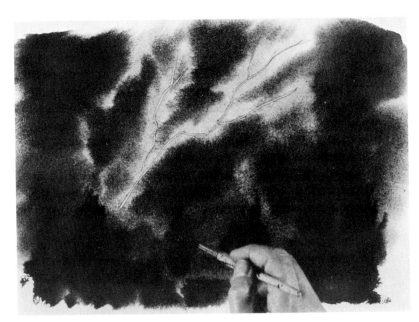

5. *Using the same colors as before, I complete the clouds, trying to keep the washes out of the pure tint of raw sienna. Next I paint in the tree shapes almost in silhouette, using burnt sienna, sap green, permanent blue, and India ink with a No. 6 round brush in heavy mixtures wet-in-wet. I use sap green and permanent blue on the green side in the center section of the foreground to give the feeling of an open field.*

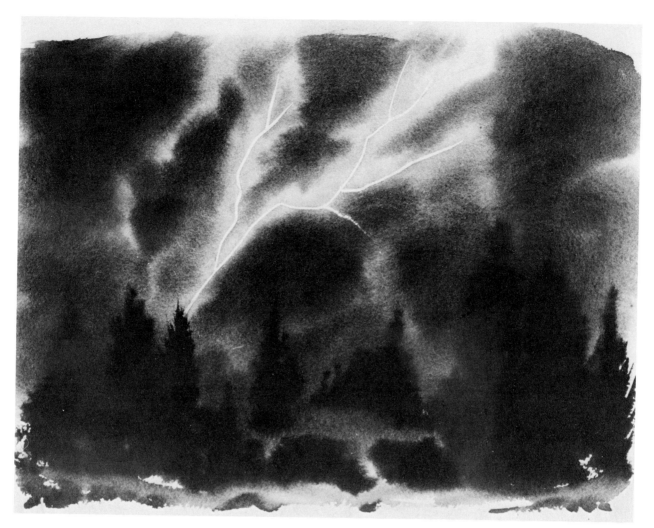

6. *I complete the foreground. When the painting is dry, I peel off the masking tape, and the white paper shows through giving the effect of lightning.*

DEMONSTRATION 16
SNOWSTORM

In this demonstration I want to convey the mood of a heavy snowfall where distance gets lost in the haze of snow. My palette will be burnt sienna, olive green, raw umber, cadmium red, cobalt blue, and white tempera. My tools are three brushes — a 1″ flat round, a No. 10 round, and a No. 6 round. I'll use a sheet of 300 lb Arches cold-pressed paper that is soaked and stretched. I draw the simple design on it with a No. 2 pencil.

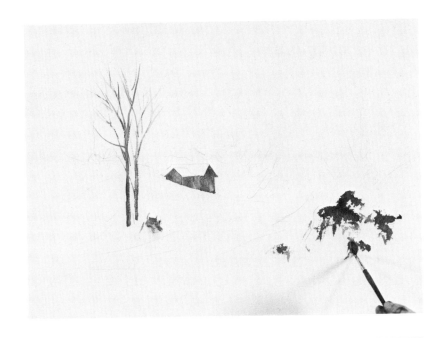

1. *I paint in the house using cadmium red and cobalt blue with a No. 6 brush. I paint in the trees and rocks using cobalt blue and burnt sienna with the same brush.*

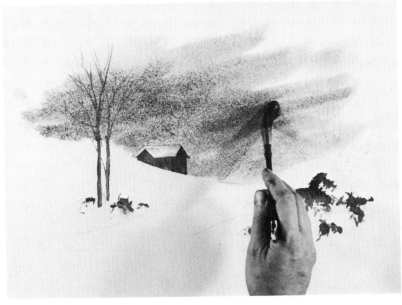

2. *I complete the rock formations and let the painting dry. I wet the sky area with a sponge and a No. 10 round brush, wetting quickly over the dry washes of the house, but cutting out the shape of the slope. Then with a 1″ flat round brush I paint the sky in, using cobalt blue, burnt sienna, and cadmium red, making it a gray-purple.*

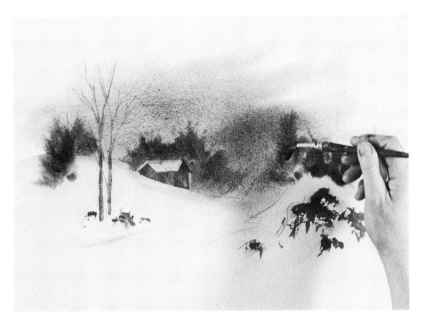

3. With the No. 10 brush, I paint in some pale washes of neutral gray for snow shadows and drifts, mixed from cobalt blue and burnt sienna. Then, I work olive green, cobalt blue, and raw umber wet-in-wet into the sky for distant trees. The group in back of the house is grayer and warmer. I use the same warm cool greens and browns on the left side for the trees. The group of trees on the right side is varied, some green and cool and some warm.

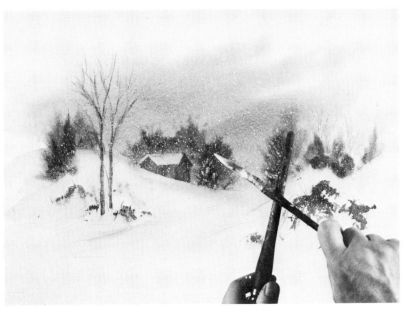

4. I add some more trees around the house, keeping them cooler gray-greens to complement the trees they mesh with, and I add a suggestion of shrubs in the middleground. When the painting is completely dry, I dip the No. 10 round brush into white tempera and smack it against a heavy brush handle to test the spatter on a sheet of newspaper. When the dots look the right size, I spatter the painting.

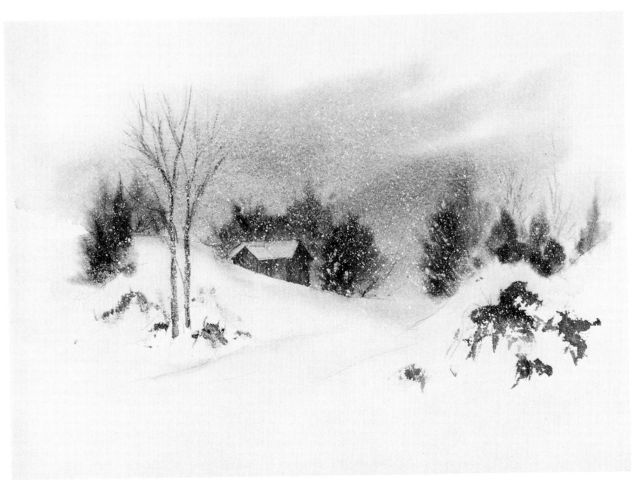

5. *I use a little more of the spatter treatment, and the painting takes on the feeling of heavily falling snow.*

Mist has always fascinated me. To wake up in the morning and find an entirely different world closed in about me has always caught me off guard. What seems unreal is very intriguing, especially in this spring scene in New York's Central Park.

I'll use burnt sienna, permanent blue, cobalt blue, olive green, sap green, cadmium red, and black India ink. My tools will be No. 6 round, 1″ flat round, and 1¼″ flat brushes and a natural sponge. A sheet of 300 lb cold-pressed Arches watercolor paper is stretched on a heavy ¾″ plywood board, and I'm ready to start.

DEMONSTRATION 17
SPRING MIST

1. Using a No. 6 round brush with cadmium red and permanent blue, I delicately paint in the distant buildings on dry paper and let them dry.

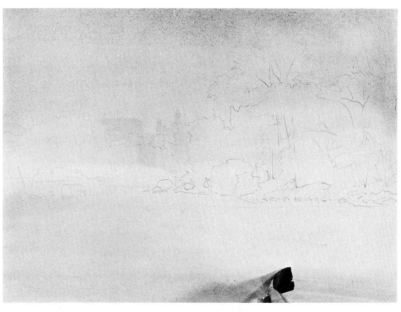

2. Then I wet the entire board by dumping a jar of clean water over it and allowing the excess to run off. I paint mixtures of permanent blue, cobalt blue, and burnt sienna into the wet surface with a 1¼″ flat brush to render the sky in flat, graded values, darker at the top to lighter at the horizon area. I also paint the water in wet with the same colors but reverse the gradation.

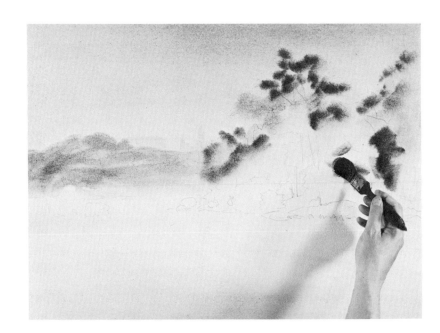

3. I paint in swatches of olive green, sap green, and permanent blue with the 1″ flat round brush for distant trees on the left side. I place the same colors into the wet sky to start the development of closer trees.

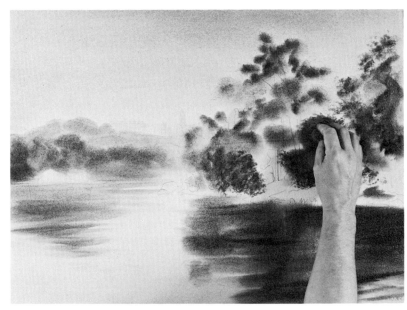

4. I paint in washes of olive green, sap green, and burnt sienna wet-in-wet with the same brush on the right side for further development of the water. I use burnt sienna and permanent blue on the left side to deepen the water. Then I stipple in the tree area using cobalt blue, permanent blue, and sap green to render the smaller trees and bushes.

5. I drag a sponge with the same colors vertically through the distant trees on the left. I stipple in burnt sienna, permanent blue, raw sienna, and India ink to finish the tree groupings on the right. I add tree trunks using the No. 6 round brush with burnt sienna and India ink. I define a small structure and rocks at the bottom of the distant trees. I use permanent blue and raw sienna with the ¾″ flat sable brush to render the rock and the reflections in the middleground. With the same colors, I use the ¾″ flat sable brush to render textures and rocks on the shoreline on the right as well as their reflections in the water.

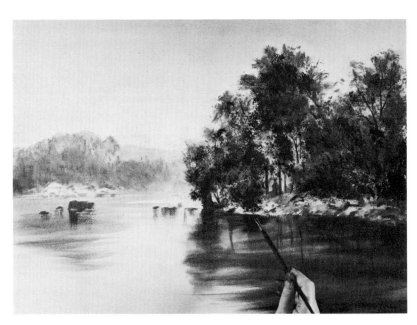

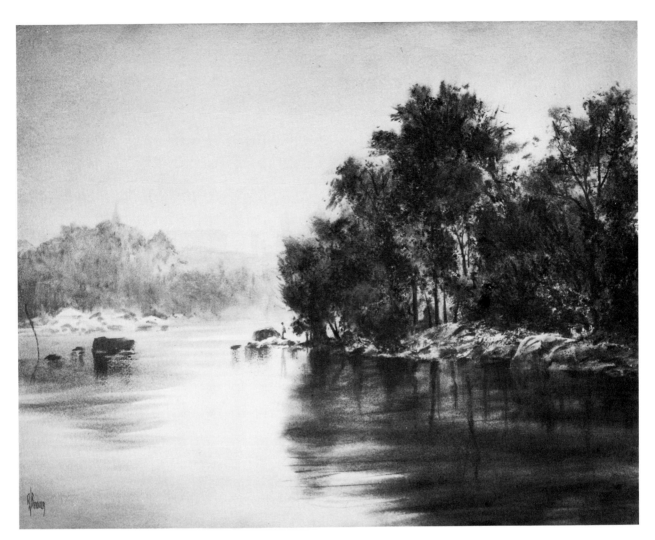

Central Park. I subdue and integrate the shoreline grass and rocks by drag-
ging permanent blue and burnt sienna with the ¾" brush over the existing
paint in that area. Then using cobalt blue and permanent blue, I paint in
the larger rocks and the boy. I add the pole on the left last, to help stop the
eye from traveling out of the picture. Then I viewed the entire picture and
found it wanting. My eye ran out the left side. So I rewet the sky, trees,
and water on that side with a fixative blower. Next I drop permanent blue
and burnt sienna off the No. 10 brush and let the paint run into position
to deepen that whole area. Then I let it dry. Now my eye holds to the
lighter central part of the painting somewhat better. I place a few washes
over some jumpy spots in the foliage, and the picture is finished.

ROCKS, HILLS, AND MOUNTAINS

DEMONSTRATION 18
SNOW-COVERED ROCKS

In this demonstration I'll show a simple rock formation covered with snow. I'll play warm and cool colors strongly against each other. My palette is cadmium red, permanent blue, olive green, burnt sienna, and black India ink. The tools I'll use are a ¾" flat sable brush, No. 10 and No. 6 round brushes, a folded cardboard squeegee, and masking tape. I prepare a sheet of 300 lb Arches cold-pressed paper in the usual manner.

1. I place a piece of ½"-wide masking tape over the birch tree. I can see my drawing through the one layer of tape and I cut out the shape of the tree with an X-Acto knife, peeling the outer excess away. I wet the sky area down to the top of the snow with clean water and a sponge. I paint in a strong wash of cadmium red and permanent blue for the sky with the No. 10 brush. Next I paint in the trees using the No. 6 round brush with permanent blue and olive green. I use burnt sienna and black India ink for textures and branches, worked in with the same brush. I let this area dry.

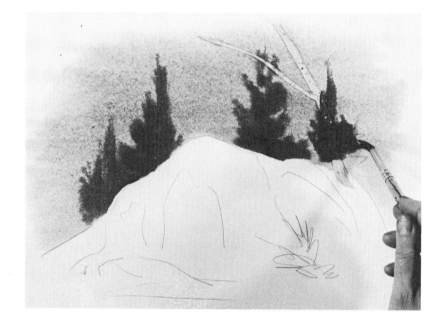

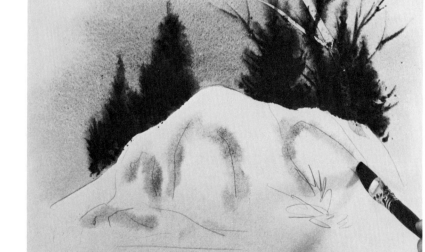

2. I wet the snow and rock area. Then with the ¾" flat brush, I put shadows on the snow to show the form of the snow around the rocks, using burnt sienna and permanent blue mixed unevenly on the cooler side of the mixture.

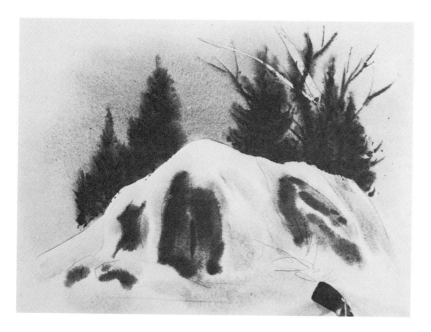

3. *I paint in the rock pattern with the same colors and brush. Then I quickly put shadows on the snow in the foreground with permanent blue and burnt sienna.*

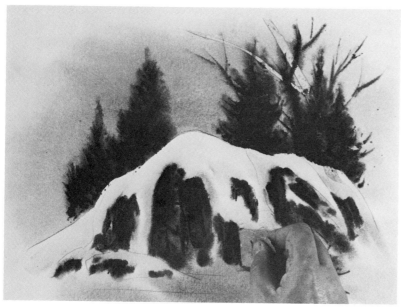

4. *I use a folded piece of cardboard to pick up undiluted permanent blue and burnt sienna on one edge. I then squeegee these colors into the damp paper for stronger definition of the rocks.*

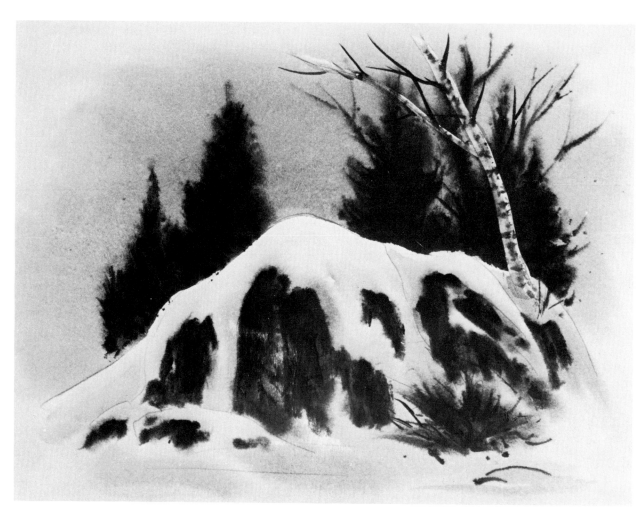

5. Next I paint in the small bush using olive green and diluted black India ink for the main body of color and burnt sienna and black India ink for the branches. Then I pull the masking tape off the birch very gently and wet it with clean water. With a No. 6 brush, I use permanent blue and burnt sienna to render the texture of birch bark. I use a little drybrush and dry squeegee on the rocks, and the demonstration is complete.

In this demonstration I will work wet-in-wet until the paper dries and then use drybrush for the finish. This painting depicts summer trees and growth on rolling hills. My palette consists of burnt sienna, raw sienna, cobalt blue, permanent blue, olive green, and black India ink. I'll use a 1″ round flat brush, No. 6 and No. 10 round brushes, a sponge, and a stretched sheet of 300 lb Arches cold-pressed watercolor paper.

SUMMER HILLS, SUMMER GROWTH

1. With a sponge and clean water, I double-wet the surface of the paper. I make sure to work the moisture in well enough to keep the paper wet for the entire painting. Then for the sky I paint in with the No. 6 round brush a wash of cobalt blue and permanent blue softened with a touch of burnt sienna. I use a mixture of permanent blue, cobalt blue, and cadmium red to start the formation of the distant mountain.

2. I carry these colors downward for the rest of the mountain and strengthen them here and there to suggest form. This is a base wash and will be painted over later. I paint the closer mountain ranges wet-in-wet, using the No. 6 brush with sap green, raw umber, and permanent blue in very deep values. When I apply the paint at this point, it has a heavy consistency.

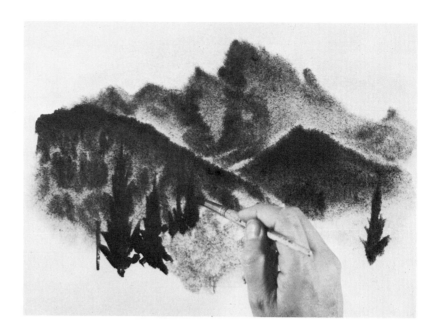

3. *I paint in raw sienna for the start of some small foreground trees. Then to begin rendering the dark pine trees, I work in with the No. 6 round brush a thick pasty consistency of permanent blue, sap green, and black ink warmed up here and there with burnt sienna.*

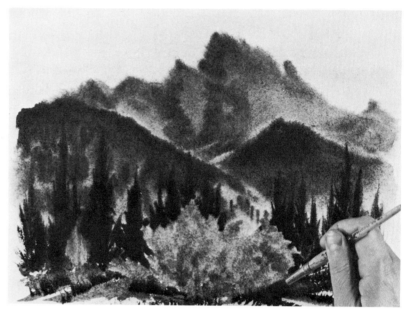

4. *I carry this on throughout the area and around the smaller trees to complete the pines. With the same brush, I paint in the foreground with sap green and burnt sienna plus a little black India ink.*

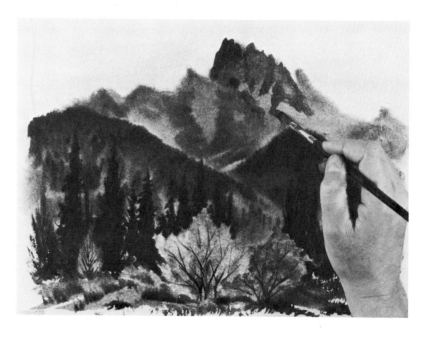

5. *I paint branches in the smaller foreground trees with black ink and burnt sienna using the No. 6 round brush. When the mountain is dry, I paint in further definition of the rock formations with permanent blue and burnt sienna, using the ¼″ flat brush.*

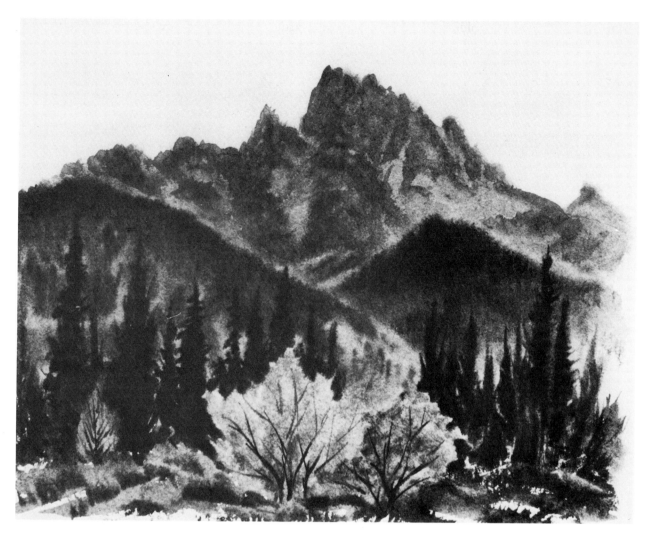

6. I sharpen these formations here and there for clarity, but still keep them soft enough to appear in the distance. The picture is complete.

DEMONSTRATION 20
MOUNTAINS WITH SNOW

Here I use the folded paper or light cardboard squeegee technique to render rocks jutting through the snow. The advantage of this over a brush is actually its lack of control — contrasted with the good control a brush affords. The cardboard squeegee transfers the pigment to the paper in a sporadic, casual manner more or less as nature places rock patterns in the snow.

I'll use permanent blue, burnt sienna, olive green, and black India ink. A sheet of Arches cold-pressed watercolor paper is stretched and ready for use. For tools I use a natural sponge, a No. 6 round watercolor brush, and a folded piece of light cardboard or heavy paper.

1. I thoroughly wet the mountain and sky areas with clean water and sponge it off to a damp consistency. I fold a piece of light cardboard or heavy paper once or twice and scoop up raw, undiluted color — permanent blue and burnt sienna — onto one edge. I use this as a squeegee to press and drag color into the moist paper. The colors mingle together, break up, and disperse into the damp surface in a scintillating array of warm and cool colors. The edge of the paper squeegee can also be used for sharper accent.

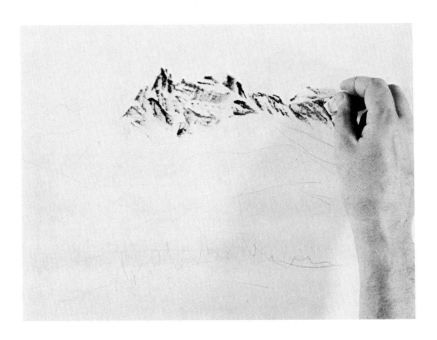

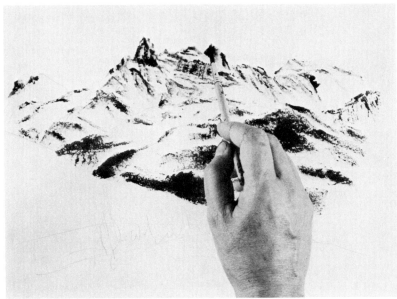

2. I carry the same procedure throughout the entire mountain range to near completion and then shape up a few rough, less meaningful areas with the No. 6 round brush.

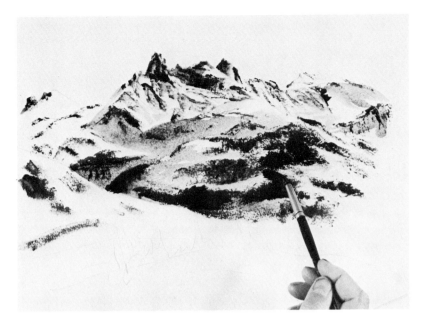

3. Now when this is dry, I paint in a wash of burnt sienna and permanent blue on the cool blue side to simulate shadows on the snow.

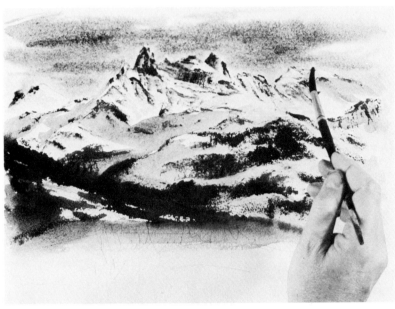

4. With the same brush, I paint in some deeper tones of permanent blue and burnt sienna for a snow slope in the middleground. Then with clear water I wet the sky area behind the mountains and cut the wet edge clean around the mountain tops. With the No. 6 round brush, I paint washes of permanent blue and burnt sienna on the cooler side of the mixture into the wet area for cloud formations.

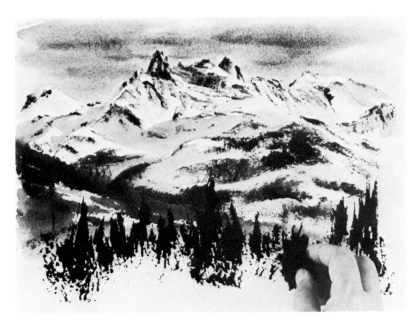

5. I dip a natural sponge into olive green, burnt sienna, and ink and stipple in the close-up pine trees.

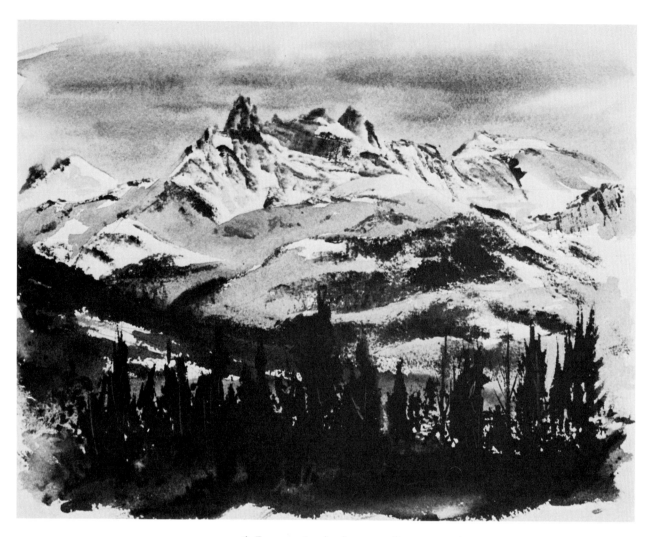

6. *For grass I paint in some olive green and permanent blue with the No. 6 round brush. I add some more textures and small pines with the sponge and brush to finish this study.*

My object here is to depict summer growth on mountains in the simplest way, using a combination of brush and sponge. It is always best to use tools that will accomplish the most with the least amount of work.

My palette consists of cadmium red, permanent blue, raw sienna, olive green, burnt sienna, and black India ink. My tools are a natural sponge and a No. 6 round brush. I stretch a 300 lb sheet of Arches cold-pressed paper on a board, and I'm ready to go.

MOUNTAINS WITH SUMMER GROWTH

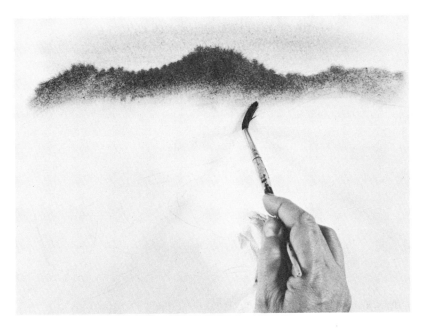

1. I wet the sky area with a sponge and clean water and paint in with the No. 6 round brush a soft blue wash of permanent blue touched with burnt sienna for sky atmosphere. Then with the same brush I start to paint a deeper mixture wet-in-wet of permanent blue, burnt sienna, and cadmium red into the sky for distant mountains, letting them run into a soft edge at the mountain tops.

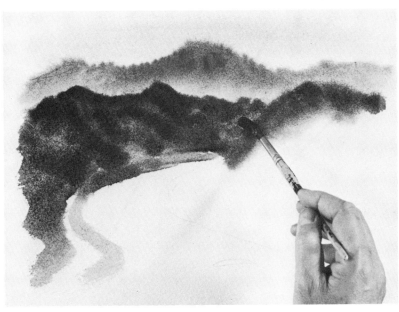

2. After I finish this area and it settles into the paper, I work wet-in-wet richer and darker mixtures of permanent blue, raw sienna, and olive green for the closer mountain ranges, dragging these washes down around the river edges.

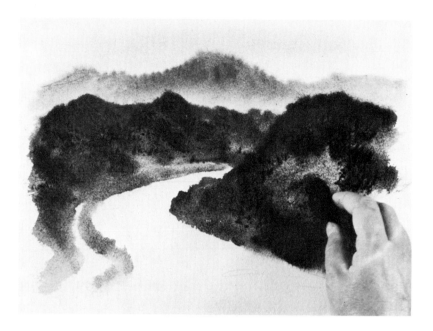

3. While these areas are still damp, I use mixtures of the same colors on a sponge plus black India ink and stipple in texture to simulate tree growth.

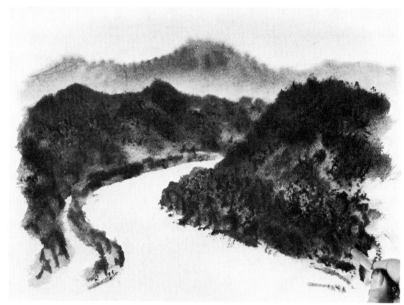

4. I use the No. 6 round brush with permanent blue and black ink to paint in larger trees in the areas closer to the foreground to help pull them together. I leave these areas to dry.

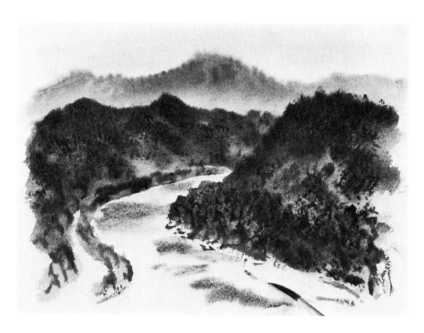

5. I now rewet the river area with the brush and run in washes of permanent blue and burnt sienna mixed on the blue side to start rendering the water. I'll keep this area simple since the mountains are the main theme.

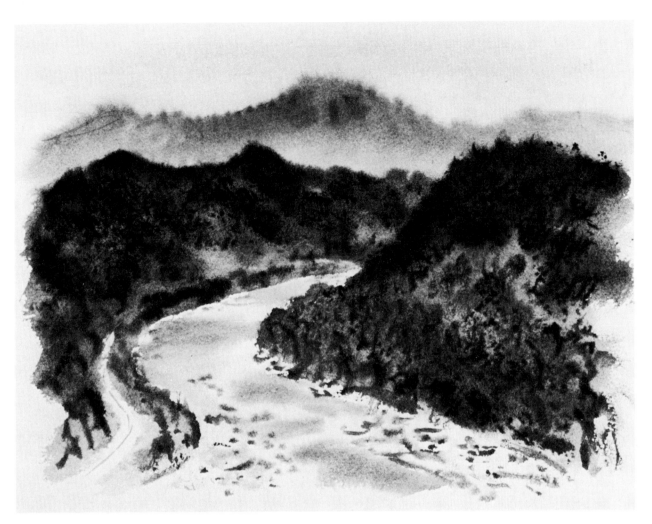

6. *I continue working on the water and put in a suggestion of rocks wet-in-wet, using burnt sienna and permanent blue on the warm burnt-sienna side of the mixture. With the same colors, I suggest a road on the left, and the picture stops here.*

DEMONSTRATION 22
BARE MOUNTAINS IN SUMMER

Here I want to render the simple feeling of mountains of earth and rock appearing in the distance, with a growth of pines silhouetted in the foreground, against which smaller leaf trees appear. For this demonstration I'll use permanent blue, cobalt blue, cadmium red, raw umber, sap green, burnt sienna, and black India ink. My tools will be a No. 6 round brush, a ¼" flat sable brush, and sponges. I soak a sheet of 300 lb Arches cold-pressed paper and stretch it on a drawing board ready for use.

1. With a sponge, I wet the top section of the paper with clean water and paint in washes of burnt sienna and cobalt blue for clouds with the 1" flat round brush. Next with the No. 10 round brush, I poke in areas of cobalt blue between the washes for broken patches of blue sky. I let this whole area dry completely. Then I pour a container of clean water over the entire board and let it run off. When the area is damp, I briskly paint in washes of raw sienna and permanent blue with the 1" flat round brush.

2. I strengthen the same mixes of colors into deeper values using the same brush to render the hills.

3. Now I work in olive green, permanent blue, and raw sienna, keeping the color mixes warm and yellowish in the center to cooler, greener, and deeper at the outer edges. Next, using the 1″ flat round brush, I put in dark thick mixes of permanent blue, raw sienna, and olive green to start the trees and growth on the hills.

4. The paper is beginning to dry, and I further develop the growth with the sponge technique, using the same three colors plus black India ink.

5. Now the paper is almost completely dry, and I develop the area still further with the No. 6 round brush using permanent blue, olive green, and ink. I insert small trees and shape up other areas, using the drybrush approach until it's completed.

6. I use the same colors with ink to finish developing the various kinds of growth. Finally, with the No. 6 round brush, I put in the bare trees with branches and the fence, using black ink with a touch of raw sienna and permanent blue.

For this picture of late evening sunlight on the snow, I'll boldly paint the strong light and shadow patterns first and then super-impose the rest of the design on this in a wet-in-wet technique.

My palette consists of burnt sienna, raw sienna, cobalt blue, permanent blue, cadmium red, and black India ink. I'll use my usual assortment of brushes and sponges plus a crumpled piece of paper. I'll draw the outline of the painting on a sheet of Arches 300 lb watercolor paper stretched on a ¾" plywood board.

WINTER WOODS, SNOW AND ROCK

1. I double-wet the lower half of the paper with a sponge and clear water. Then I flood bold washes of cobalt blue, permanent blue, and burnt sienna on the paper with a 1¼" flat brush.

2. With a 1¼" flat brush, I distribute the same mixtures of colors through-out the rest of the foreground to es-tablish the light and dark patterns. Next I use a sponge with permanent blue and burnt sienna to start to put in textures.

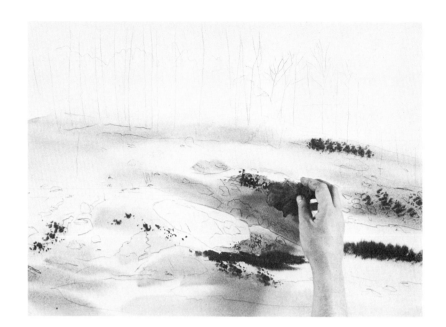

3. *I continue the textures with sponge and the same colors to render rocks and growth.*

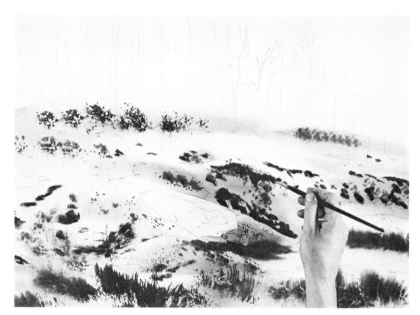

4. *I put in more growth with the same technique. I use a small ¼″ flat sable brush with burnt sienna and permanent blue to place in more of the smaller rocks and to shape up others.*

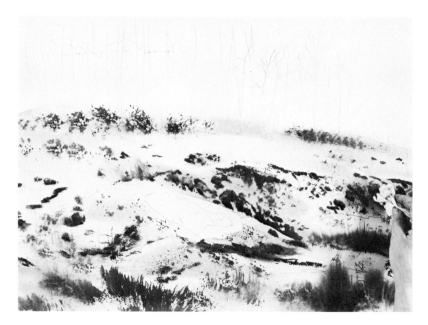

5. *I use a piece of crumpled paper to stipple in thick mixtures of the same colors. This gives a varied rendering of the small rocks coming through the snow.*

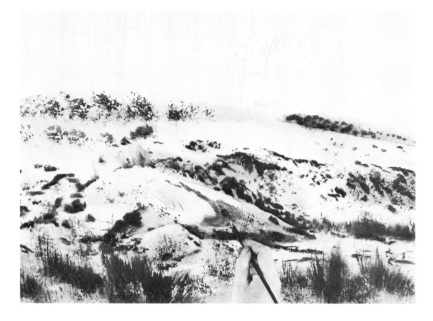

6. I use the small ¼" flat sable brush once again to further the sporadic design and pattern of the rocks. I use a sponge with burnt sienna and permanent blue and very lightly stroke in the tall dried weeds in the foreground. With the ¼" flat brush, I start to render the large rock, using raw sienna and burnt sienna with a touch of cadmium red as a light base of color. I finish this off with mixtures of permanent blue and burnt sienna as shadow tones.

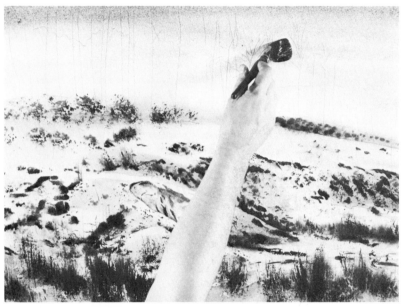

7. Next I wet the entire wood and sky area and wash in raw sienna. Then I brush pure cobalt blue into this, grading it downward slightly with the 1¼" flat brush.

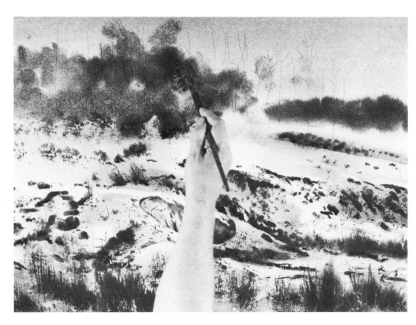

8. I use the ¾" flat sable brush and vigorously swish in mixtures of cadmium red and cobalt blue wet-in-wet as a base color for distant woods on the right and the wooded area on the left.

9. *While the paper is still wet, I sponge permanent blue and burnt sienna into the wooded area. Then with a small No. 6 round brush, I put in the bare trees using burnt sienna with lots of India ink. The colors melt together for a soft, diffused effect.*

Edge of the Woods. *(Below) I stipple this still-damp area slightly with a sponge and permanent blue and burnt sienna to give a feeling of a maze of branches. Then I complete it with burnt sienna and ink and a No. 6 brush. I squeeze pigment out of the moist paper with a brush handle to give the appearance of distant birches. Now the painting is finished. (See page 96 for color reproduction of this painting.)*

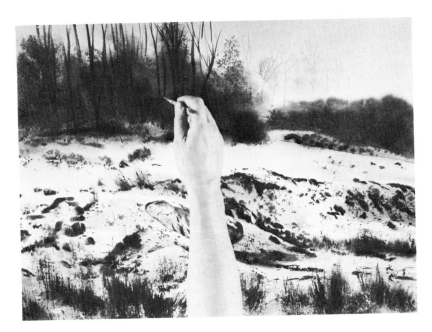

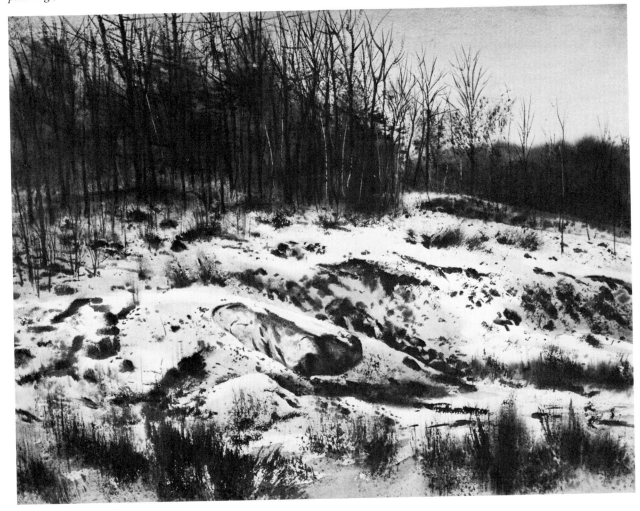

WALLS, FENCES, AND ROADS

DEMONSTRATION 24
STONE WALL

The approach here will be wet-in-wet with a drybrush finish. This is only one possible approach, but I decide to use it for better integration of color and texture. My palette consists of raw umber, burnt sienna, sap green, cobalt blue, and black India ink. A No. 6 brush and a sponge are my only tools. A sheet of 300 lb cold-pressed Arches paper is stretched, taped, and stapled in place.

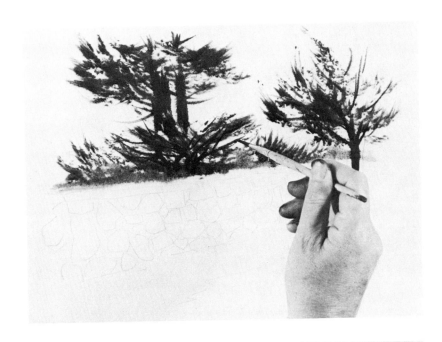

1. I double-wet the top half above the wall with clean water so the moisture will last longer. I intermingle raw umber, sap green, and black ink on a natural sponge and use it like a brush to suggest branches and leaves. Then I use the No. 6 brush with ink and co-balt blue to render the trunks and heavier branches of the trees. I use sap green and raw umber to place in the green grass and shrubs on the upper level behind the wall.

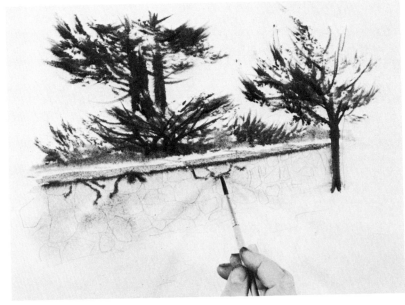

2. I wet the wall with clean water and wash in colors of cobalt blue and burnt sienna unevenly to create a vi-bration of warm and cool color. I use the No. 6 brush with thick mixtures of the same colors to render the stone-topped ledge and the stone masonry.

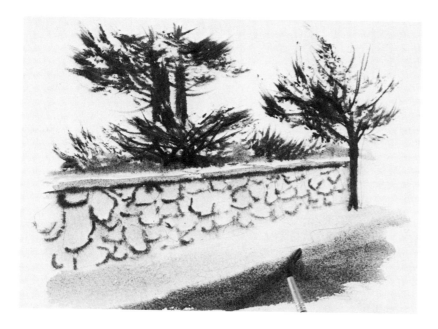

3. *I carry this out wet-in-wet until the masonry is completed. Then I paint in the portion below the wall with a pale tint of burnt sienna. I place in cobalt blue and burnt sienna on the cool blue side to suggest a road.*

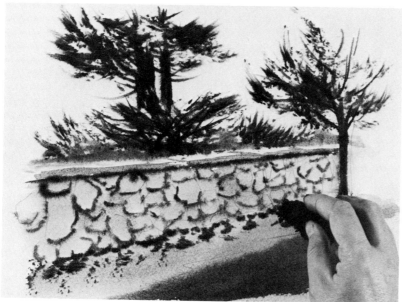

4. *I stipple in with a sponge dipped in burnt sienna and a touch of black ink to suggest tufts of grass and dried leaves at the bottom of the wall.*

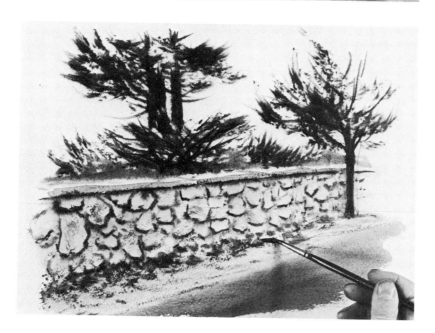

5. *By this time the area is pretty dry, so I sharpen and crisp up the stones in the wall slightly with a little drybrush, using black India ink and a No. 6 round brush. I drybrush sap green into the grass and leaves with the same brush.*

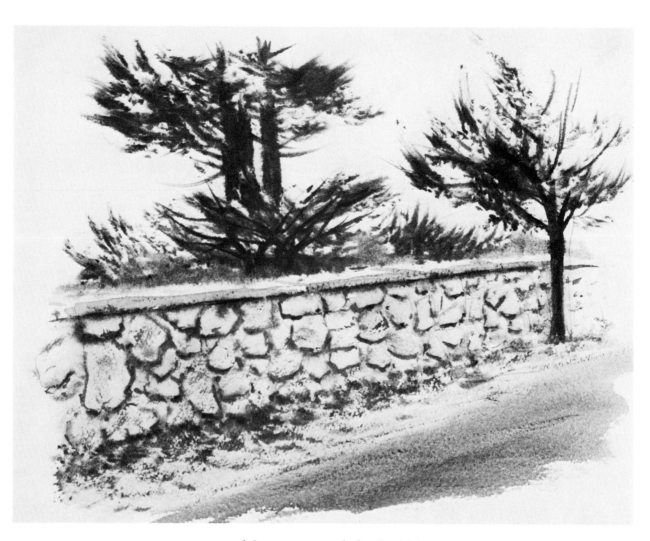

6. I use some more drybrush with burnt sienna and cobalt blue for the road and the wall to complete the demonstration.

This demonstration shows the construction of an object made from nature, that is, the hewn shapes of split rails in a wooden fence. I keep my palette simple — permanent blue, raw sienna, burnt sienna, plus black India ink. A natural sponge and No. 10 and No. 6 round brushes will be the tools I'll use to render the picture. A sheet of 300 lb Arches watercolor paper is stretched, I draw the design with a No. 2 pencil, and I'm ready to paint.

DEMONSTRATION 25
SPLIT WOODEN FENCE

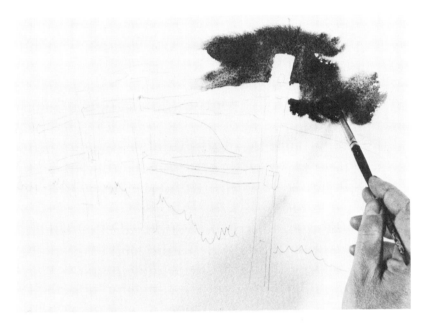

1. *I wet the paper with a No. 10 brush and clean water, cutting around the fence and road. I paint in mixtures of permanent blue, raw sienna, and black ink for distant foliage using the same brush. As the washes go on, I see I have missed wetting a spot or two and decide to go with this for a different effect.*

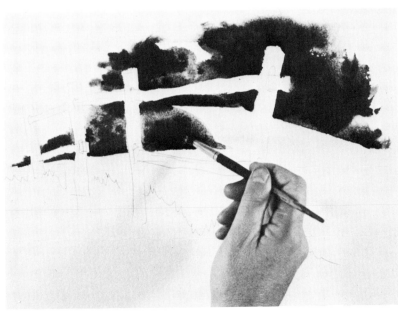

2. *I continue this same approach in and around the road and fence using the same colors.*

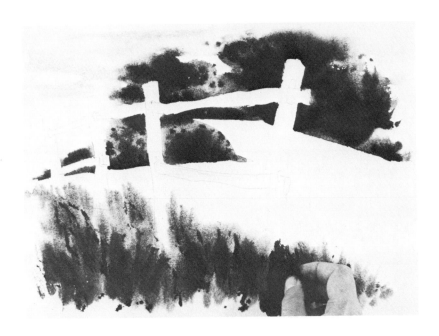

3. With the No. 10 brush, I paint in light washes of permanent blue, grayed slightly with burnt sienna, to render a cool gray sky effect. With a sponge, I wet the bottom foreground section with clean water. I paint in permanent blue and raw sienna with a No. 10 brush for foreground bushes. I use the sponge with burnt sienna and black ink to further render weeds and growth.

4. For the roadway I paint in graded washes of permanent blue and raw sienna on the cool side of the mixture. When this is dry, I wet the fenceposts with clean water and paint them individually, using burnt sienna and permanent blue on a No. 6 brush.

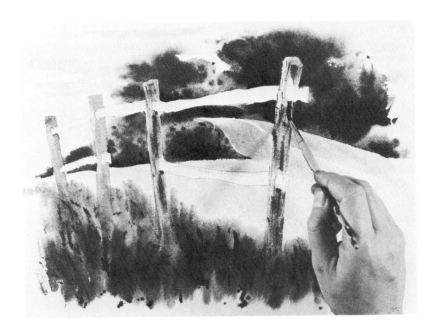

5. I continue the same process, and as the posts dry slightly, I add texture to them, using thick mixtures of burnt sienna and permanent blue with the same brush.

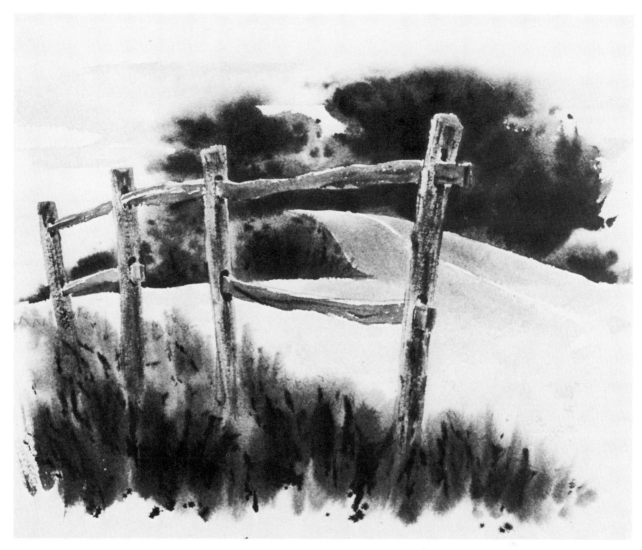

6. *Last, I add a little drybrush with burnt sienna and permanent blue to finish the rough, dry feeling of old wood. I use little accents of the thick, dark colors plus ink to place slots in the fence posts. The demonstration is now complete.*

DEMONSTRATION 26
WET ROAD IN SPRINGTIME

This watercolor depicts the vivid outburst of a spring day, refreshed by an afternoon shower. The familiar scenes of daily life — the wet pavement and the passing clouds — prompted me to paint this picture. My palette consists of permanent blue, cobalt blue, Winsor red, cadmium red, raw umber, burnt sienna, raw sienna, olive green, sap green, and black India ink. I assemble the same sponges and brushes, and I stretch a sheet of 300 lb cold-pressed Arches paper on a drawing board.

1. I wet the top half of the sheet down to the roadway at the bottom of the trees. I flood a very pale wash of burnt sienna into this area with the 1¼″ flat brush. With the same brush I paint a very wet gray mixture of burnt sienna and permanent blue and leave it to settle and smooth out. Then I sponge in a mixture of raw sienna and olive green while the sky is still wet to start rendering the spring greens.

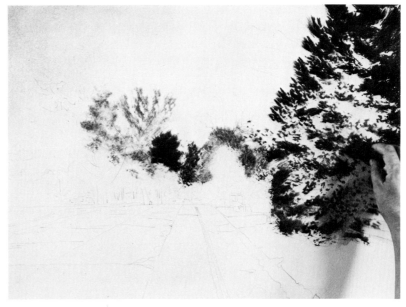

2. I introduce sap green into this mixture to pick up a brighter green. With the No. 10 round brush, I put in some permanent blue, olive green, and burnt sienna for a small pine. I put down a mixture of raw sienna and cobalt blue for a base shadow color for the white dogwood. Then I cut around the dogwood using a No. 10 round brush and sponge in the still-damp sky to render the large pine grouping behind the dogwood with permanent blue, olive green, and black ink. I also lightly stipple the dogwood with the same sponge and colors to render it and also show the dark pine behind it.

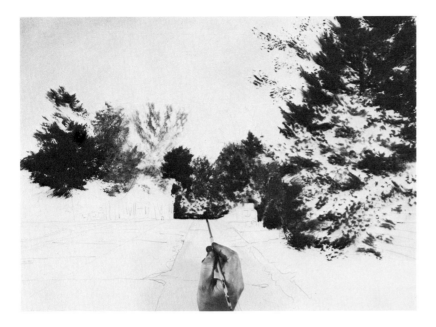

3. I lightly stipple some dry texture into the sky area for the budding trees in back of the large pine. I use a No. 6 brush to shape up the ends of the pine branches with the same colors before the area dries completely. With the same brush, I paint the pink dogwood with cadmium and Winsor reds and the white dogwood with cobalt blue and raw sienna and then surround them with darker trees using burnt sienna, permanent blue, sap green, and olive green.

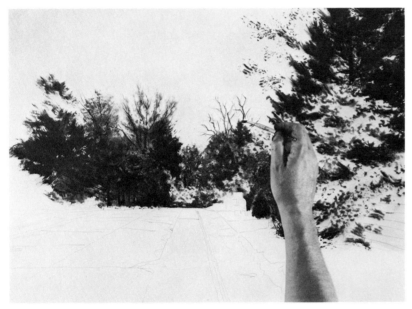

4. I then lightly stipple this area with the sponge using permanent blue, burnt sienna, and a touch of India ink for better foliage effect. I place in the bottom portion of the trees on the left, using the darker colors for foliage and burnt sienna and India ink for tree trunks. I use the small No. 6 brush to paint in the bare tree with ink and burnt sienna.

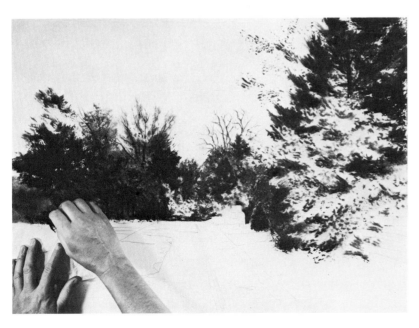

5. I add a light wisping of the sponge with the same colors for better texture in the foliage area. I use a piece of paper to mask out the road edge and then sponge in the rest of the shrubs with deep colors of cadmium red, sap green, and India ink.

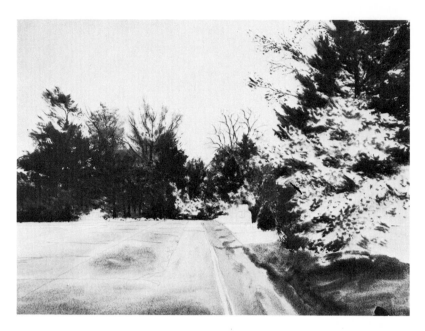

6. *I wet the bottom part of the paper with a sponge and clear water. Then, with the 1″ round flat brush, I paint in washes of purple mixed from cobalt blue, cadmium red, and Winsor red, alongside washes of raw umber, burnt sienna, and permanent blue for the road. I paint in the grass using raw sienna, raw umber, and sap green. For shadows I use permanent blue and burnt sienna with a ¾″ flat brush.*

7. *I strengthen and deepen the washes on the road using burnt sienna and permanent blue on a ¾″ flat brush to slip the color on the paper more easily. I suggest small reflections from distant trees on the pavement to help create the illusion of wet concrete.*

8. *I rewet the grass section with a 1¼″ large flat brush and clear water, and then using permanent blue, sap green, burnt sienna, and India ink with a sponge, I texture and deepen the grass to keep it subordinate to the viewing eye.*

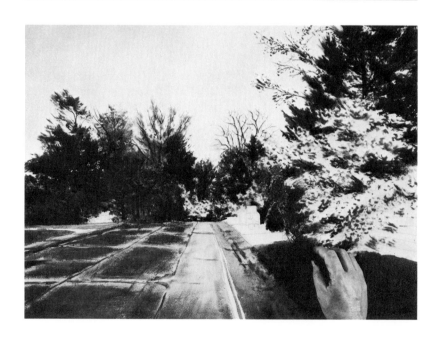

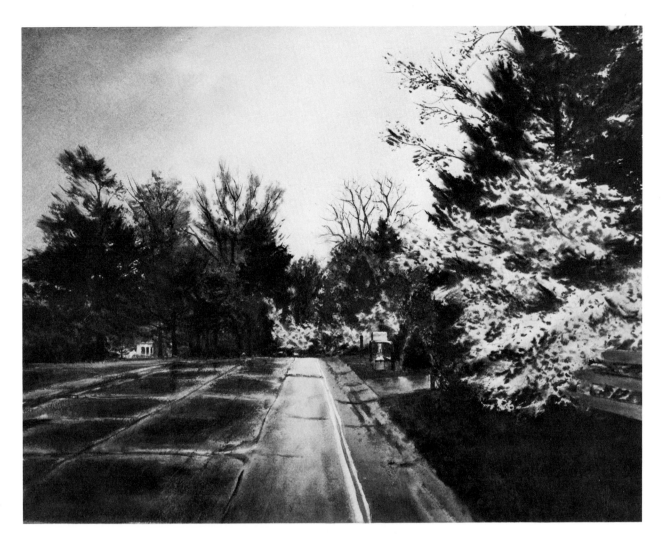

Colfax Avenue. With a No. 6 round brush, I put in the small house on the left as well as the milk can and mail box, using cobalt blue and burnt sienna. I also paint in the wooden fence, using raw sienna, permanent blue, and burnt sienna, keeping the fence low keyed and quiet in the field of vision. I use the same brush with burnt sienna, permanent blue, and olive green to give a little more texture to the large dogwood. I study the picture in a mat to see if it's satisfactory. The sky does not work just right; it seems a bit too open. So I rewet the left side of the sky with a fixative sprayer and clean water and mix permanent blue and burnt sienna on the neutral gray side in a puddle on my palette. I then proceed to drop heavy mixtures of this into the wet sky from my No. 10 brush and let it swim around. By picking up and tilting the board, I reach the desired effect. Now I lay the board flat and let it dry. This deepening of the sky in the left corner leads the eye to the lighter area in the center much better. With a little extra texture added to the large dogwood, the picture seems complete. (See page 96 for color reproduction of this painting.)

Many problems can arise when painting a watercolor, and it becomes necessary to find, discover, or invent different ways to alter or correct areas and certain passages that are not working out to your satisfaction.

The areas could be too dark or too light; the colors could offend, lack harmony, or be overworked. Maybe you wished you'd used a simpler approach, or you just need to be able to know how to rewet and paint a deeper wash into an area or add textures to pep up an otherwise stale area. These situations bring up the question: How can I accomplish this in the most knowledgeable way? To answer that question I'll show you the techniques — and the tricks — I use to correct areas of paintings that don't please me. I've developed some of these myself, and I apply them at that stage in the painting when I see the problem arising.

Adding New Elements

Sometimes a painting has been sitting around in a 90 percent finished state for months and sometimes it is completely finished and framed when the overpowering urge compels me to seriously consider adding more elements in the wild chance of improving it. Yet, now is the time for restraint. Consider the idea, but never jump at the decision to inject new elements into a finished painting, especially if you're not sure of the final outcome.

Instead, take a large piece of prepared acetate and tape it to the top of the painting so it can swing up and off the painting with ease. Now paint your new design or element on this acetate that has been treated to take ink and water. Now you can study it for days to see how it works. Is it helping or just cluttering up the picture? Whatever, *live* with the change for several days. Remember that a new addition of this type can be exciting when first viewed, but may be dead wrong for what the picture really needs.

For painting or changing a passage in a picture that has already been framed and that you consider to be finished but that you know really never worked, paint right on the framed glass with opaque paints, and live with that change for several weeks. With this technique you could repaint the foreground and sections of skies, add trees, and have a great time without altering the original product.

Sometimes in trying to achieve white paper by adding an element that is essentially white or that you wish to appear white, you can simply scratch out the area carefully with an X-Acto knife and then smooth out the scratched paper with an electric eraser. Small washes can then be painted in with little paint disturbance or paper eruptions that could distract the eye.

All the changes I've discussed here should be done sparingly and only when you feel they are absolutely necessary.

Correcting Small Details

It is in the small areas that scraping out, erasing, and repainting work fairly well. Another method that I use quite frequently is

PROBLEMS AND HOW TO CORRECT THEM

Before adding new elements to a finished painting, I experiment by trying them out first on an overlay of prepared acetate.

to mask out, by cutting paper friskets or using masking tape. For frisketing, mask around the area to be altered and sponge it out with clean water, blot it dry, remove the frisket, and paint in the alteration. It is sometimes quite impossible to reach white paper by sponging out, but most alterations can be adjusted to this and work out well. One example is how I added another rock covered with snow in *Winter Stream*.

Altering Foregrounds

The foreground of a painting, like all other passages, has to function in relation to the other parts so the picture will work as a whole. Most foregrounds have the large responsibility of leading the viewer's eye through it, into it, or over it into the main theme of the painting. Usually foregrounds are much easier to alter than sky washes, by painting over with a second wash, adding texture, or sponging out and repainting with fresh washes.

Sometimes in studying a painting that just doesn't meet the requirements, I'll get the feeling that the foreground could be much too light, attracting the attention of the eye to it instead of to the meat of the picture. One way to help make sure that deepening that whole area would be correct is to have a strong single source of light and cast a shadow over the foreground so that you can see how it would look if a second, deeper wash were thrown over it. You can use a spotlight as a single light source and a piece of cardboard to cast a shadow. This method of dodging could be used for other areas as a way to clarify your thinking.

If you decide that the foreground needs deepening, prepare the necessary mixture and quickly paint in over the existing values using the direct dry approach, always keeping the value deeper than the anticipated final results, so it will dry to the correct value. As it begins to dry, texture can be added or values strengthened if necessary.

Another way to deepen the foreground is to drybrush the area with deeper tones. This will help lower and integrate the value.

I have sponged and repainted foregrounds in several paintings up to four or five times in a wild attempt to salvage an otherwise good picture. Sometimes it is a better idea after the paper has been abused and scuffled by several attempts to let the foreground thoroughly dry after the last sponging out. Then the next day you can examine it with a fresh outlook, see what is needed, and paint it in to your satisfaction.

Sometimes you may decide that the foreground is too heavy and dark. Use a natural sponge and clean water to sponge out the entire foreground and paint it in quickly, making the proper adjustment in value and color. Another time the foreground can be in correct value, but too busy with texture, constantly pulling your eye away from the central and more interesting theme. If you drybrush and integrate the textures, it would probably deepen the foreground value too much. Usually sponging out and repainting the treatment is the only recourse to follow.

In *Catermount #2* I painted in the stone wall by the roadside, but it seemed too heavy and caught my eye. I removed it with

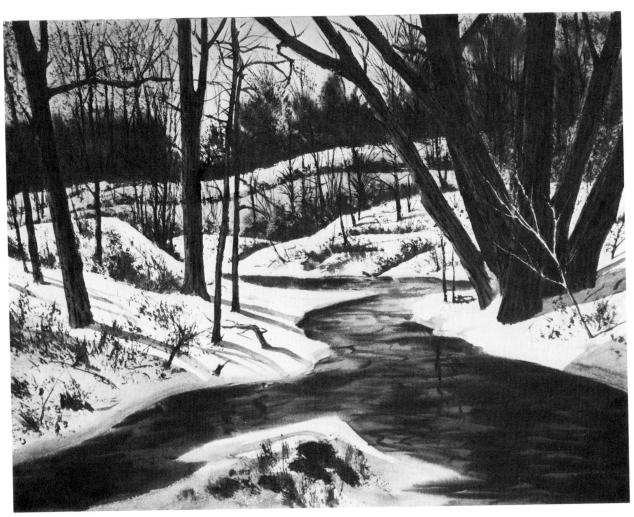

In Winter Stream *I felt the right foreground was too dark and held the eye too much.*

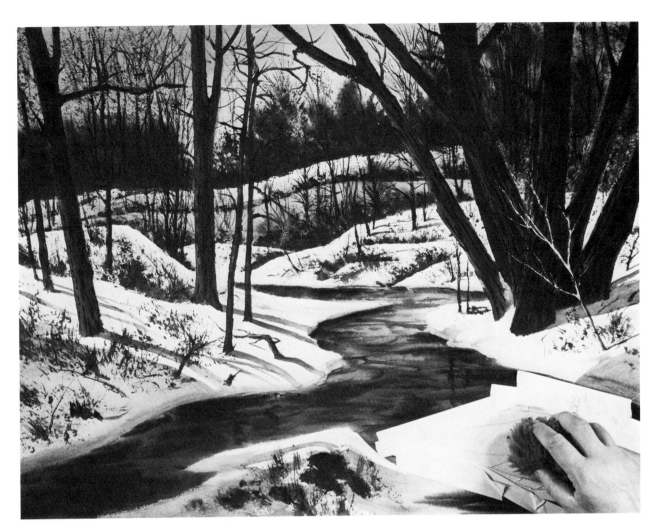

I decided to add another rock covered with snow in the stream. I masked around the area and sponged it out with clean water.

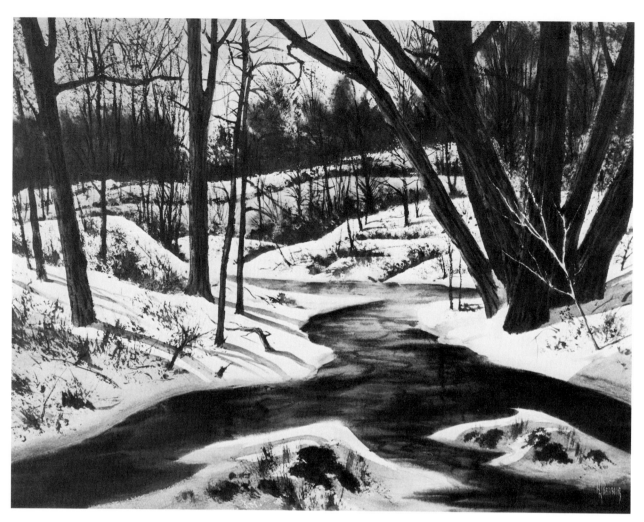

Then I blotted it dry, removed the frisket, and painted in the rock. Now the painting seems more balanced and complete.

clean water and a natural sponge, and you can see the improvement.

Altering Skies

There are several steps an artist can take to alter or salvage a painting when the trouble spot seems to be in the sky. Some of the techniques or manipulations are quite simple, while others are involved and depend on whether the composition allows for change without disturbing other elements in the picture. So you can see that several approaches could be considered. The choice will be determined by the requirements of the painting.

The first and best approach is when you are painting the sky for the first time. While the area is still wet, but not meeting with your approval, sponge it out. This removes practically all the pigment with the least damage to the paper, and you can repaint it easily for a more pleasing effect. You must always keep in mind when painting cloud effects, like other large washes, that the washes will always dry out lighter. This can confuse you when deciding whether or not the area is too strong and should be sponged off.

When it comes to skies that are set and dry, it is rather difficult to sponge them out and repaint them without losing that fresh, luminous quality. This is mainly because some of the old pigment is stubborn and the sponging required to remove most of it alters the surface of the paper, which in turn alters the freshness of the wash. Although this is acceptable for other areas in a painting, a sky usually should be clean, fresh, and airy.

Before you decide to follow the above procedure, I strongly suggest you consider the following alternatives.

Making the Sky Lighter. If the sky seems too dark and overpowers the painting, perhaps strengthening some of the other elements, deepening their value to create a greater contrast, will make the sky appear lighter by comparison. Another maneuver to consider would be to crop or cut off the sky area if the composition permits, thus reducing its influence in relation to the rest of the painting.

If the sky is a small area with a simple wash that appears too deep, I usually rewet it gently with a large flat brush, trying not to overlap the strokes for fear of lifting the underpigment unevenly. I then blot it by laying a piece of paper towel over it, rubbing it gently but evenly with the heel of my hand in the hope of removing an even amount of paint. If some of the pigment should streak, blotch, or be lifted off by the blotting, it can always be rectified by taking a small No. 1 or No. 2 watercolor brush and stippling small dots of the same color into these damaged areas. You will be surprised that you can actually match them up. Several watercolors of mine have been fixed this way after being scratched or scraped. Also watermarks can easily be taken care of in the same manner. Wet and blot out the dark fringe area of the mark and stipple the same color into the lighter blotch to match the existing value.

If you have to sponge out a sky that's just too dark for the

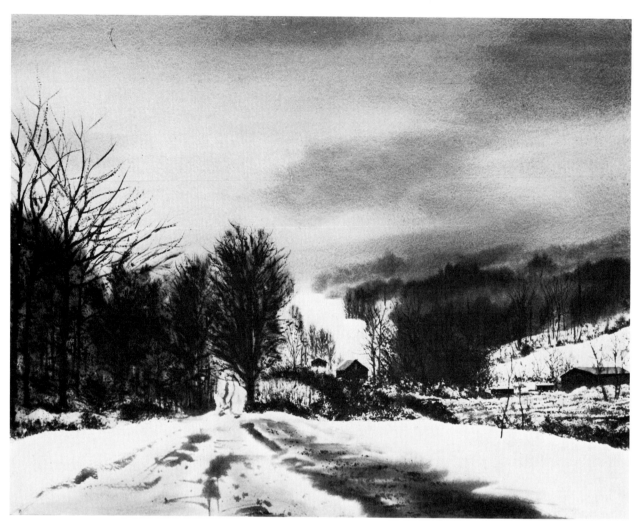

In Catermount #2, *I wasn't satisfied with the foreground on the left side of the road as I had originally designed it.*

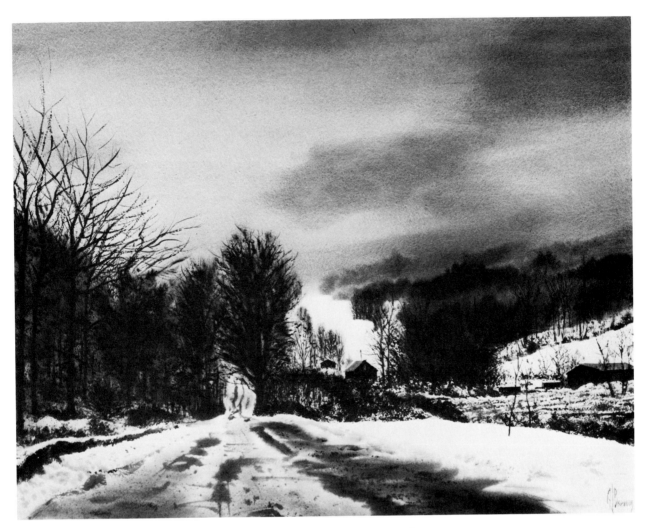

I painted in the stone wall by the roadside, but that seemed too heavy and caught my eye, so I decided to change my original plan.

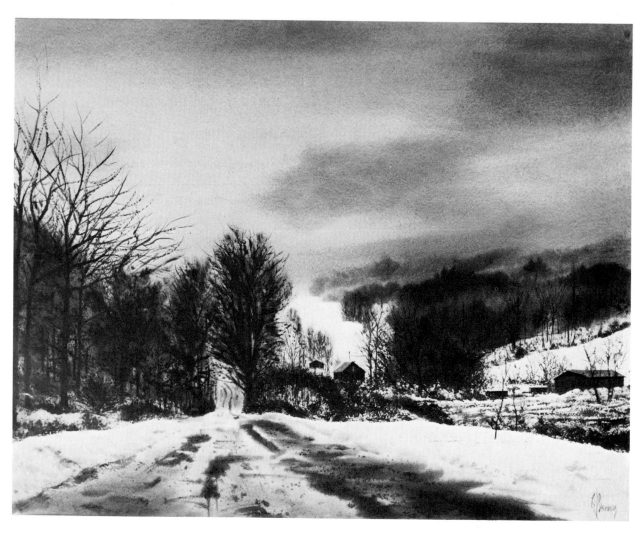

I removed the wall with clean water and a sponge, leaving a little texture. That improved not only the foreground, but the whole picture.

picture, be sure to mask out any shapes or important areas — especially hard-edged objects — next to the area to be removed. If the objects are trees or other diffused elements, you may have to sponge part of them out also and put them back in after you paint the new sky. Use a natural sponge and clean water to remove the dried pigment. Keep sponging and changing the water until the paper is almost white. Then gently paint in the new sky with fresh paint.

Making the Sky Darker. There are different ways to deepen the value of an existing sky wash that is too light. One way is to mix a puddle of color in the palette. Don't mix the deeper value on the paper or you will disturb the original sky wash. Then take a flat brush and gently run the deeper value over the original sky and let it dry.

Here is another method of rewetting and adding deeper tones in any part of an existing sky. You might want to do this to concentrate the light area more toward the center of the painting. Cover the parts of the painting that you do not wish to disturb when rewetting, with either heavy paper or cardboard. Then take a fixative sprayer and blow clean water over the exposed edges. You could also use some kind of spray bomb or jet pack for this purpose. When they are fairly loaded, remove the protective masks and gently tilt the board to let the excess water run off.

Now mix a batch of fresh colors on your palette, and with a No. 10 round brush, drop the color into the wet area. Tilt the board and let the color swim into place. Sometimes I work each area independently, rewetting and letting each area dry before rewetting and working the next.

This same system could be confined to the center of a picture to make subtle changes in various wet-in-wet shapes. Remember, though, that there is always the chance of spoiling a picture. Make sure the change is truly warranted before taking such risks.

There is another way to darken large sky washes. First, mix up a batch of color in a little jar to the consistency that can be blown through a fixative blower. Rewet the sky area with clean water and the blower. Wait until the area is just damp, and then blow the newly mixed paint particles into the moist sky. They should diffuse and blend in nicely, giving a uniform or a graded tone, or whatever tone you were working to obtain when you applied the paint particles.

You may want to add some dark storm clouds over a light sky. Either rewet with the fixative sprayer, or if the picture design permits, dump a jar of water over the sky and let the excess run off. Let the water in the paper settle just a bit. Then drop the fresh, deeper grays with the No. 10 round brush into the sky area. Pick up and tilt the board until the washes run into an attractive design. Lay the painting flat, let it dry, and hope for the best.

By using the above technique, I have deepened clouds and strengthened weak skies at times very successfully. For instance, I have masked out buildings, statuary, or other solid obstacles with a layer of masking tape. Remember that this can be seen

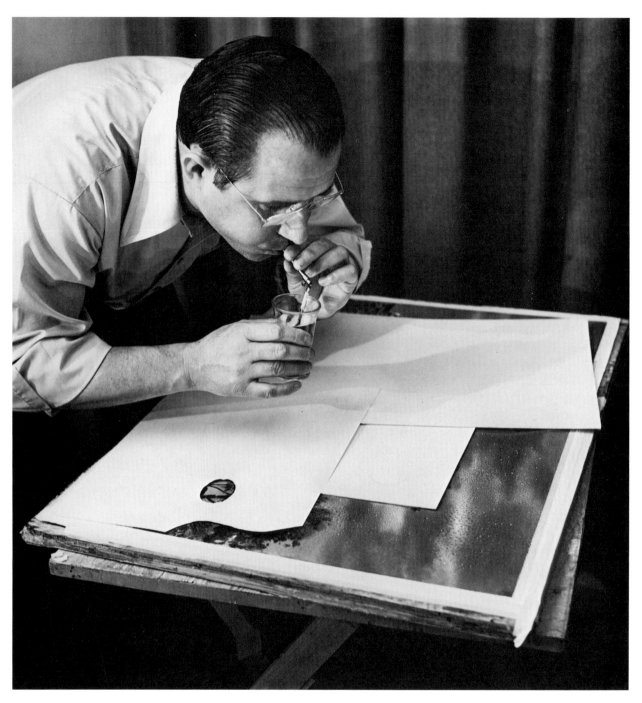

Here I want to darken an area of the sky at the edge of a painting. I cover the parts of the painting that I don't wish to disturb with pieces of cardboard. Then I blow water on the sky area with a fixative blower, add the darker colors, and tilt the board until the colors spread through the wet areas.

through. Then I cut around the shape of the object with a sharp razor or X-Acto knife, peel the excess away, rewet the whole sky as described above, drop in heavy mixtures for clouds, tilt the board until a desired effect is reached, and then gently remove the tape when the area is dry. If the existing sky is light enough in value, you can paint in the new washes very quickly and boldly using a 1″ flat brush. Sometimes you might have to smudge or work in one side of the solid object to integrate it with the sky, but overall the system works quite well.

As a final resort to rescue a painting, I have very carefully sanded the existing wash right off the paper. I have never attempted this on any weight lighter than 300 lb. I really think this should be considered only as a last resort, but by using extreme caution so as not to sand through the paper, I have successfully accomplished it. I mention this but feel a little reluctant to recommend it.

BIBLIOGRAPHY

Barbour, Arthur J. *Painting Buildings in Watercolor*. New York: Watson-Guptill; London: Pitman, 1973.

Blake, Wendon. *Acrylic Watercolor Painting*. New York: Watson-Guptill, 1970.

Brandt, Rex. *The Winning Ways of Watercolor*. New York: Reinhold, 1973.

Cooper, Mario. *Painting with Watercolor*. New York: Reinhold, 1971.

Guptill, Arthur L. *Watercolor Painting Step-by-Step*. Edited by Susan E. Meyer. New York: Watson-Guptill; London: Pitman, 1967.

Kautzky, Ted. *Painting Trees and Landscapes in Watercolor*. New York and London: Reinhold, 1952.

_____. *Ways with Water Color*. 2d ed. New York and London: Reinhold, 1963.

Kent, Norman. *100 Watercolor Techniques*. Edited by Susan E. Meyer. New York: Watson-Guptill, 1968.

O'Hara, Eliot. *Watercolor with O'Hara*. New York: Putnam, 1966.

Pellew, John C. *Painting in Watercolor*. New York: Watson-Guptill; London: Pitman, 1970.

Pike, John. *Watercolor*. 2d ed., rev. New York: Watson-Guptill; London: Pitman, 1973.

Richmond, Leonard, and Littlejohns, J. *Fundamentals of Watercolor Painting*. New York: Watson-Guptill, 1970.

Schmalz, Carl. *Watercolor Lessons from Eliot O'Hara*. New York: Watson-Guptill; London: Pitman, 1974.

Szabo, Zoltan. *Creative Watercolor Techniques*. New York: Watson-Guptill; London: Pitman; Toronto: General, 1974.

_____. *Landscape Painting in Watercolor*. New York: Watson-Guptill; London: Pitman, 1971.

Whitney, Edgar A. *Complete Guide to Watercolor Painting*. 2d ed., rev. New York: Watson-Guptill; London: Pitman, 1974.

Wood, Robert E., and Nelson, Mary Carroll. *Watercolor Workshop*. New York: Watson-Guptill; London: Pitman, 1974.

INDEX

Acetate, prepared, 143
Advent of Winter, 83
Alizarin crimson, 14, 15
Autumn Song, 71

Birch, 38–42; in snow, 38–39; in summer, 40–42
Brushes, 12, 16–18; fanning out, 16–17; flat, 18; flat round, 18; handle, as lift-out tool, 22; round, 16–18; sabelines, 16, 18
Burnt sienna, 14
Burnt umber, 14
Bushes and weeds in foreground, 43–44
Butcher's tray, use of as palette, 12, 22–23

Cadmium orange, 14, 15
Cadmium red, 14, 15
Cadmium yellow, 14, 15
Camera, use of when painting outdoors, 24
Cardboard squeegee, 19–20
Catermount #2, 145, 150–152
Central Park, 109
Coast of Maine, 63, 65 (color)
Cobalt blue, 14
Colfax Avenue, 96 (color), 141
Color(s), 13–16; behavior of, 14–15; dye, 13–14; earth, 14; mixing shadow tones, 15–16; pigment, 13–14
Come Winter, 95
Composition, tips on, 24–25
Containers, water, 23
Corrections, how to make, 143–155. *See also* Problems, how to correct

Demonstrations, 28–141; in color, 65–96
Drawing board, 22

Drybrush technique, demonstrated, 28–29, 35 53, 55, 74, 77, 90, 92, 94-95, 98–99, 114, 116–117, 119, 133–134, 137

Early Fall Shower, 91
Edge of the Woods, 96 (color), 130
Elements, new, adding to finished painting, 143
Erasers: electric, 20–21, 143; plastic, 20–21

Fall, demonstrations on: pond, 76–79 (color); shower, 88–91 (color); woods, 69–71 (color)
Fence: split wooden, 135–137; wooden, in early winter, 92–95 (color)
Fixative sprayer (blower), 12, 23, 59, 87, 109, 141, 153, 154
Foregrounds: alterations in, 145–149; bushes and weeds in, 43–44

Garrett Mountain, 87
Grays, mixing, 15–16

Hardwood tree, bare, 30–31
Hills in summer, 115–117

Ink, black India, 12, 14, 15; applying on a damp surface, 17
Inlet in winter, 56–59, 65 (color)

Knives: as lift-out tool, 22; X-Acto, 12, 22, 155

Leafed-out tree, 32–33
Lift-out tools, 20–22; electric eraser, 20–21; knife blade, 22; paintbrush handle, 22; plastic eraser, 20–21
Lighting conditions, 24

Masking out, 59, 63, 139, 153, 155
Masking tape, used as frisket, 23, 40–41, 101, 103, 112, 114, 145, 147–148
Matchbook, used as squeegee, 19–20
Matches, used to remove tube caps, 23
Meadow, in midsummer with pond, 72–75 (color)
Mist in spring, 107–109
Mixing shadow tones, 15–16
Mountain(s), 84–87 (color), 118–126; bare in summer, 124–126; with snow, 118–120; with summer growth, 121–123; in winter, 84–87 (color)

Olive green, 14, 15

Paintbox, 23
Painting outdoors, 24
Paints: behavior of, 13–14; selecting, 14–15
Palette, 12, 22–23
Paper, 11, 13, 23–24; Arches, 13; cold-pressed, 11, 13; commercially mounted on board, 13; crumpled, applying color with, 19–20; hot-pressed, 11, 13; rough, 11, 13; sizes of, 13; stretching, 23–24; surfaces of, 11, 13; towels, 23, 149; weights of, 13
Pencils, 12, 23
Permanent blue, 14
Pine tree, 34–37; in snow, 34–35; in summer, 36–37
Pond, 72–79 (color); in autumn, 76–79 (color); in midsummer with meadows, 72–75 (color)
Problems, how to correct, 143–155; adding new elements, 143; in foregrounds, 145–149; in skies, 149–155; in small details, 143

Rainstorm, in spring, 98–100
Raw sienna, 14
Raw umber, 14
Road: in early fall, 88–91 (color); wet, in spring-time, 96 (color), 138–141
Rocks, hills, and mountains, 84–87 (color), 96 (color), 112–130; hills in summer, 115–117; mountain in winter, 84–87 (color); mountains with snow, 118–120; mountains, bare, in summer, 124–126; mountains with summer growth, 121–123; rocks, snow-covered, 112–114; rocks in winter woods with snow, 96 (color), 127–130
Rocks, snow-covered, 112–114; in winter woods, 96 (color), 127–130

Sandpaper, 155
Sap green, 14, 15
Scraping out, 22, 48, 58, 143

Seacoast in summer, 60-63, 65 (color)
Shadow tones, mixing, 15–16; diagram of, 15
Shower in early fall, 88–91 (color)
Skies, alterations in, 149–155
Snowstorm, 104–106
Softwood tree, bare, 28–29
Sponges, natural, 12, 18–20
Sponging in color, 32–33, 41, 43–44, 46, 54, 66, 69, 72–73, 76–78, 80, 82, 87, 88–89, 92–93, 108, 117, 119–120, 125, 127, 130, 133, 138–140
Sponging out color, 59, 145, 149, 153
Spring, demonstrations on: mist, 107–109; rain-storm, 98–100; wet road, 96 (color), 138–141; woods, 66–68 (color)
Squeegee: applying color with, 20, 53, 62, 84–86, 113, 118; matchbook cover used as, 19–20
Stippling, 18, 29, 32–33, 35, 40, 34–44, 72, 74–75, 77, 82–83, 87, 89–90, 92–93, 108, 119, 125, 128, 133, 138–140
Stream: with rocks in summer, 50–52; with woods in fall, 69–71 (color)
Summer, demonstrations on: birch, 40–42; hills, 115–117; leafed-out tree, 32–33; mountains, bare, 124–126; mountains with growth, 121–123; pine, 36–37; pond, 72–75 (color); rain-storm, 98–100; seacoast, 60–63, 65 (color); stream with rocks, 50–52; thunderstorm, 101–103; waterfall, 53–55; woodland path, 45–48
Sunglasses, 24

Table, work, 22
Tape: carton-sealing, 23; masking, 23. *See also* Masking tape
Thunderstorm in summer, 101–103
Tools, 12, 16–23; brushes, 12, 16–18; electric eraser, 12, 20–21; fixative sprayer, 12, 23; knife, X-Acto, 12, 22; masking tape, 12, 23; matchbook, 12, 19–20; palette, 12, 22–23; paper towels, 12, 23; pencil, 12, 23; plastic eraser, 20–21; sponges, natural, 12, 18–20; tape, carton-sealing, 12, 23; watercolors, 12; water container, 12, 23
Towels, paper, 23, 149
Trees, 28–48, 66–71 (color), 80–83 (color); birch in snow, 38–39; birch in summer, 40–42; bushes and weeds, 43–44; hardwood, bare, 30–31; leafed-out, 32–33; pine with snow, 34–35; pine in summer, 36–37; softwood, bare, 28–29; woodland path in summer, 45–48; woods in fall, 69–71 (color); woods in late spring, 66–68 (color); woods, in winter, no snow, 80–83 (color)

Ultramarine blue, 14

View from Water Street, 75

Wall, stone, 132–134
Walls, fences, and roads, 92–96 (color), 132–141; split wooden fence, 135–137; stone wall, 132–134; road, wet, in springtime, 96 (color), 138–141; wooden fence in early winter, 92–95 (color)
Wanaque Inlet, 59, 65 (color)
Washes, illustration of: on a dry surface, 16; on a wet surface, 17
Water, 50–63, 65, 72–79 (color); autumn pond, 76–79 (color); inlet in winter, 56–59, 65 (color); midsummer's pond, 72–75 (color); seacoast in summer, 60–63, 65 (color); stream with rocks in summer, 50–52; waterfall in summer, 53–55
Water container, 12, 23
Waterfall in summer, 53–55
Weather effects, 88–91 (color), 98–109; early fall shower, 88–91 (color); snowstorm, 104–106; spring mist, 107–109; spring rainstorm, 98–100; summer thunderstorm, 101–103
Wet-in-wet technique, demonstrated, 30, 34–48, 50–63, 66–95, 98–109, 112–130, 132–141
Whisper of Spring, The, 68
Winsor red, 14, 15
Winter, demonstrations on: birch, 38–39; inlet, 56–59, 65 (color); mountain, 84–87 (color); mountains with snow, 118–120; pine, 34–35; rocks, snow-covered, 112–114; snowstorm, 104–106; wooden fence, 92–95 (color); woods, no snow, 80–83 (color); woods, with snow and rock, 96 (color), 127–130
Winter Stream, 145–148
Woodland Path in Summer, 48
Woods, 45–48, 66–71 (color), 80–83 (color); in fall, 69–71 (color); in late spring, 66–68 (color); in summer, 45–48; in winter, no snow, 80–83 (color); in winter, with snow, 96 (color), 127–130
Work table, 22